A TIME OF YOUTH

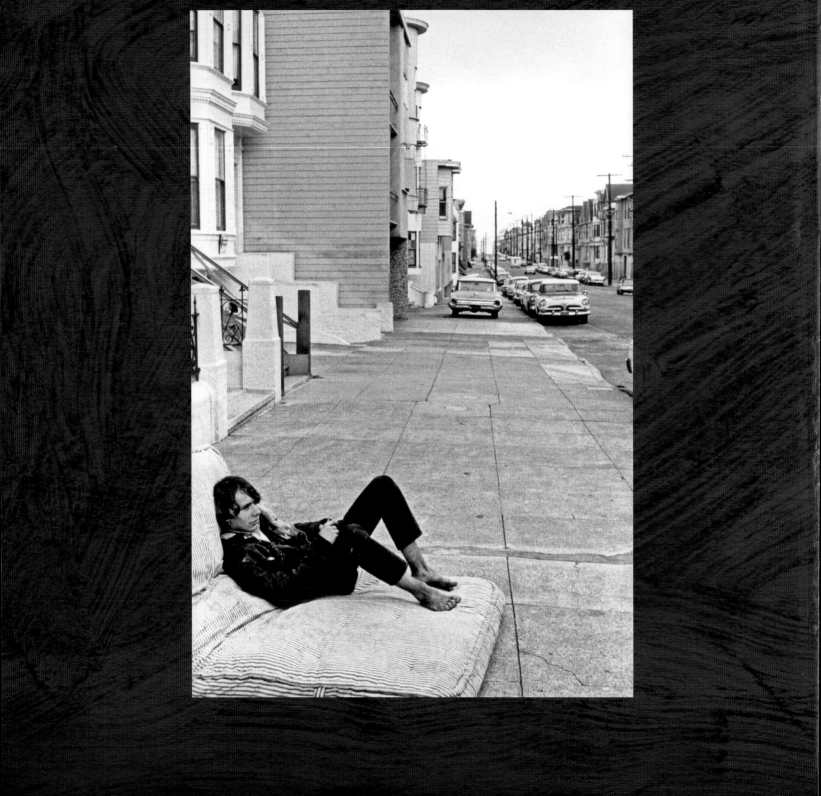

A TIME OF YOUTH

San Francisco, 1966–1967

William Gedney

EDITED BY LISA MCCARTY

WITH AN ESSAY BY PHILIP GEFTER

PUBLISHED BY DUKE UNIVERSITY PRESS

IN CONJUNCTION WITH THE DAVID M. RUBENSTEIN

RARE BOOK & MANUSCRIPT LIBRARY

Durham and London • 2021

Designed by Amy Ruth Buchanan
Typeset in Kepler by Copperline Book Services

Library of Congress Cataloging-in-Publication Data
Names: Gedney, William, –1989, author. | Gefter, Philip, writer of supplementary
textual content. | McCarty, Lisa, [date] editor.
Title: A time of youth : San Francisco, 1966–1967 / William Gedney ;
edited by Lisa McCarty ; with an essay by Philip Gefter.
Description: Durham : Duke University Press in conjunction with the
David M. Rubenstein Rare Book & Manuscript Library, 2021. |
Identifiers: LCCN 2020024603
ISBN 9781478010555 (hardcover)
Subjects: LCSH: Gedney, William, –1989. | Documentary photography—California—
San Francisco. | Photography—California—San Francisco. | Youth—California—San
Francisco—Social life and customs—Pictorial works. | Photographers—
Diaries. | Photography, Artistic.
Classification: LCC TR654 .G436 2021 | DDC 770.9794/61—dc23
LC record available at https://lccn.loc.gov/2020024603

Cover art: William Gedney, *San Francisco, 1966.* William Gedney Photographs and
Papers, David M. Rubenstein Rare Book & Manuscript Library, Duke University.

DUKE UNIVERSITY PRESS GRATEFULLY ACKNOWLEDGES
THE DAVID M. RUBENSTEIN RARE BOOK & MANUSCRIPT LIBRARY
AT DUKE UNIVERSITY, WHICH PROVIDED FUNDS TOWARD
THE PUBLICATION OF THIS BOOK.

CONTENTS

4.16.69

This book is an attempt at visual literature, modeled
after the novel form (characters progress throughtout
the book and other literary devices are used in the format).

I worked for the collective impression, yet tried to make
each of the individual pictures stand on their own.
The book tries to bring pictures together in a strict
dramatic sequence. Perhaps this is an impossible task
to set for a photographer working in reality, measured
by time and chance.

The photographs were made while on a Guggenheim
fellowship in 1966-67. I wandered the streets of
San Francisco, these were the people I met, this was
how they lived.

The book is designed in a square format to allow for the
equal size of both horizontal and vertical pictures.
The present size is 8 1/2 x 8 1/2 inches, this size can
be altered (as long as the basic proportions remain the
same) depending on press and sheet size etc.
It now runs approximately 100 pages without any
introductory matter.

William Gedney

Statement accompanying Gedney's final design for *A Time of Youth*, 1969. William
Gedney Photographs and Papers, Box 161, Folder 7, David M. Rubenstein Rare Book &
Manuscript Library, Duke University.

INTRODUCTION

LISA MCCARTY

> One historical-existential trace has been hunted, captured,
> guarded, and preserved in aversion to waste by an avid collector,
> then shut carefully away, outside an economy of use, inaccessible
> to touch. Now it is re-animated, re-collected (recollected) through
> an encounter with the mind of a curious reader, a researcher,
> an antiquarian, a bibliomaniac, a sub sub librarian, a poet.
> —Susan Howe, *Spontaneous Particulars:*
> *The Telepathy of Archives*

Dear Reader,

The book you hold in your hands has been reanimated after fifty years of dormancy. William Gedney completed a maquette for *A Time of Youth* in 1969, and he intended for the book to be seen, read, and held close, as is evidenced in a typewritten statement of his from the same year (see the accompanying image). Gedney carefully saved these manuscripts, along with sixty thousand additional items that documented his life and work, for twenty years as he moved between various home studios in Brooklyn and finally to Staten Island. When William Gedney's life was tragically cut short by AIDS in 1989, when he was fifty-six, the future of his archive, and thus his legacy, was precarious. In some ways this was not surprising, given the nature of Gedney's life and work.

William Gedney was born in New York and was based there for most of his life. He was most active as a photographer from the mid-1950s through the mid-1980s and traveled

throughout the United States, as well as in India and Europe. He had an impressive résumé, which included a solo exhibition at the Museum of Modern Art, New York (MoMA), as well as Guggenheim and Fulbright Fellowships. Gedney's contemporaries included the celebrated photographers Diane Arbus and Lee Friedlander, who knew Gedney and supported his work. However, his approach and interests as a photographer were distinctive from those of the school of New York street photographers with whom Gedney is often associated. Over the course of his career, Gedney focused on photographing specific communities in which he embedded himself for extended periods. To do this, Gedney took jobs intermittently as a graphic designer, a librarian, and later an educator to support himself. He tended to keep these positions until he had saved enough money to photograph for several months at a time without the constraints of a day job. This approach, and Gedney's propensity to work rather than to self-promote, allowed for prolificacy but brought him little commercial gain or acclaim.

Gedney worked toward what he referred to as "photographic essays."[1] He undertook long-form explorations of his own neighborhood in Brooklyn, a family of coal miners in Eastern Kentucky, everyday life in Benares (Varanasi), India, and youth counterculture in San Francisco, the last of which is presented in this book. For each of these projects, Gedney spent months photographing and often years corresponding with the people he came to know. Such a work ethic demonstrates Gedney's commitment but also his long-term exploration of precariousness, both in his own life and in the lives of others. To quote the former director of MoMA's Department of Photography, John Szarkowski, Gedney photographed "people living precariously under difficulty."[2] In the 1968 press release for Gedney's solo show, Szarkowski also noted, "Gedney's pictures make it clear that individuals are more complex and interesting than the clichés. . . . The pictures reward us with real knowledge of the lives of specific people."[3] The photographs in *A Time of Youth* certainly reward us with such knowledge and complexity.

In a sequence of eighty-seven photographs, Gedney presents the intertwined lives of young friends and lovers. We can see the intensity of these relationships in singular gazes, gestures, and embraces, both on the streets of San Francisco and in makeshift shared beds on apartment floors. Within these improvised spaces, swagger and self-consciousness are rendered visible through Gedney's tight framing and sympathetic eyes. He made all the photographs in *A Time of Youth* between 1966 and 1967 while living for several months with the communities he photographed. Gedney was able to undertake a project of this length only through the support of a Guggenheim Fellowship that he received in 1966. In

his application he wrote, "I have pursued this as far as I can with personal means, being constantly interrupted by the necessities of earning a living, to support the expenses of photography. A grant will allow me to do what I cannot do as a journalist: cover in depth areas of American life that are largely ignored or that the mass media are reluctant to cover. It will give me freedom to devote all my time, thought, and effort to photographing America as I see it."[4]

In the course of his thirty-year career, Gedney made approximately seventy-six thousand unique images that speak to precarity in different ways. However, much of this work has come to be known only posthumously by virtue of Gedney's archive, which found not only a home but a long line of stewards. After three years of uncertainty, Gedney's archive came to the David M. Rubenstein Rare Book & Manuscript Library at Duke University in 1992 as a donation from the co-executors of his estate, who included his brother and his closest friends, Lee and Maria Friedlander. In collaboration with a variety of Gedney advocates, the library has facilitated several waves of activity to promote his work and make it available. In 2000 the Duke faculty member Margaret Sartor and the writer Geoff Dyer coedited the collection *What Was True: The Photographs and Notebooks of William Gedney*.[5] Exhibitions at Duke's Center for Documentary Studies and the San Francisco Museum of Modern Art were organized to coincide with the book's release. As a result of the book and exhibits, between 2000 and 2012 Gedney's images were among the most requested photographs in the library's collection. They have been reproduced in exhibition catalogs, magazines, and textbooks. The publication in 2013 of a second book showcasing Gedney's work marked a second spike in public interest. *Iris Garden*, edited by the photographer Alec Soth, features Gedney's photographs combined with text by the composer John Cage.[6] The book was shortlisted for the Aperture Foundation's PhotoBook of the Year award but is now out of print. *Iris Garden* introduced a new generation of photographers and curators to Gedney's work and spurred much of the widespread attention that Gedney is now receiving.

From 2014 to 2019 I was privileged to serve as the curator of William Gedney's archive. Soon after my appointment in 2014, I began the project that has led to this publication. As a photographer, fellow bookmaker, and curator, I was awestruck when I found William Gedney's handmade books, book designs, and bookmaking ephemera during a reorganization of his archive. I immediately set to work on an exhibition to display these previously unseen treasures. While Gedney's images have been seen and celebrated in recent years, to date only a handful of people have seen his books. In addition to the thousands

of images and prints Gedney made throughout his career, between 1967 and 1982 he conceived, designed, and constructed seven unique photobooks. Gedney's archive also includes descriptions and in-progress designs for at least seven more book projects, making a total of fourteen books overall, which would have corresponded to his major photographic essays. While only one of the books Gedney completed in his lifetime was ever under contract to a publisher, it is clear that he believed his images should be experienced and disseminated as books.

As the former steward of Mr. Gedney's archive, I am elated to carry out what I believe to be his wishes. That said, I must acknowledge the speculative nature of this posthumous publication. This book would have been very different if William Gedney had been able to publish it in 1969. This book would be different still if Gedney were alive today and able to supervise this publication. My methodology for undertaking this reanimation of *A Time of Youth* was to preserve as many of Gedney's decisions as possible while also providing context for his extraordinary but little-known achievements as a bookmaker and archivist of his own work. As such, his image selection is presented here exactly as he composed it, in the sequence and at the scale he desired. When Gedney's decisions or intentions were not clear in his original design, I referred to his copious journals for guidance. However, there are aspects of this publication that Gedney did not specify and certainly would have had opinions about, including paper stock, printing method, and print run. The additions of this introduction, the essay by Philip Gefter, and my afterword and chronology are certainly leaps of faith.

In his application for the Guggenheim Fellowship, Gedney also wrote, "My work expresses itself completely in visual terms, never trying to duplicate what words can do."[7] The words added to this volume are not intended to duplicate or explain William Gedney's photographs. However, I hope they can provide a window into his process and perhaps paint their own parallel picture of William Gedney as an artist, a bookmaker, and a humanist.

Sincerely,

Lisa McCarty
Assistant Professor of Photography, Southern Methodist University
Curator, Archive of Documentary Arts, Duke University (2014–2019)

NOTES

Epigraph: Susan Howe, *Spontaneous Particulars: The Telepathy of Archives* (New York: New Directions, 2014).

1. William Gedney, Guggenheim Fellowship application, 1965, William Gedney Photographs and Papers, Box 166, Folder 14, David M. Rubenstein Rare Book & Manuscript Library, Duke University.

2. Museum of Modern Art, press release no. 130, for release December 17, 1968, https://www.moma.org/documents/moma_press-release_326598.pdf.

3. Museum of Modern Art, press release no. 130.

4. Gedney, Guggenheim Fellowship application, 1965, William Gedney Photographs and Papers, Box 166, Folder 14.

5. Margaret Sartor and Geoff Dyer, eds., *What Was True: The Photographs and Notebooks of William Gedney* (New York: W. W. Norton and Lyndhurst Books of the Center for Documentary Studies, 2000).

6. John Cage and William Gedney, *Iris Garden*, ed. Alec Soth (Saint Paul: Little Brown Mushroom, 2013).

7. Gedney, Guggenheim Fellowship application, 1965, William Gedney Photographs and Papers, Box 166, Folder 14.

A TIME OF YOUTH

Photographs

WILLIAM GALE GEDNEY
467 Myrtle Avenue
Brooklyn 5, New York
UL 7-2276

A Time ~~OF~~ OF YOUTH

87 photographs ~~~~ San Francisco 1966-1967

"They seem to be doing happy things sadly,
or maybe they're doing sad things happliy."

John Cage

Make-believe partakes of the nature of a magic
ritual. We not only pretend to be what we are
not, but by staging our pretense we strive to
conjure and bring into existence a new genuineness.
The strange thing is that often this conjuring
act succeeds and we become what we pretend to be.

<div align="right">Eric Hoffer</div>

NORTH LOCKHEED GATEHOUSEMAN → WHORE HOUSE
↑ONE FLIGHT UP↑

Federation Underground Committee of Korea

1107 MATERNITY —
WAITING ROOM ↓

BREST CANCERS REMOVED Rm 1107B →
AUTOS REPAIRED Rm 1107C ←

PICKWICK & SONS — PROVISIONS (FIRST LEFT)

MARY JANE GRASS COMPANY — I.L. PORCLOIN....PRES.

LIKE IS EKIL SPELLED BACKWARDS

— NO —

NEGRDES , JEWS , GYPSIES, ENGLISHMAN, ALBINOS, SALESMAN, FAGS,
HEADS, FREAKS, IRISHMEN, COPS, PUERTO RICANS, SHARKS, SHACK FREAKS,
CHRISTIANS, BASTARDS, BITCHES, SONS OF BITCHES, BARTENDERS, RAPISTS,
TRAPISTS, NUNS, VIRGINS, WHORES, PRESIDENTS, NEWTS, SNAILS, POLYWOGS,
GOLYWOGS, DWARFTS , AND ANYTHING THAT WALKS, CRAWLS, FLIES, SLITHERS
OR EXISTS UPON THE FACE OF THE EARTH WILL BE ADMITTED
UNLESS ACCOMPANIED BY A PARENT OR ADULT OVER 21 BETWEEN
THE HOURS OF 1 AM AND 12:30 AM THE MANAGMENT

LOVE = HATE

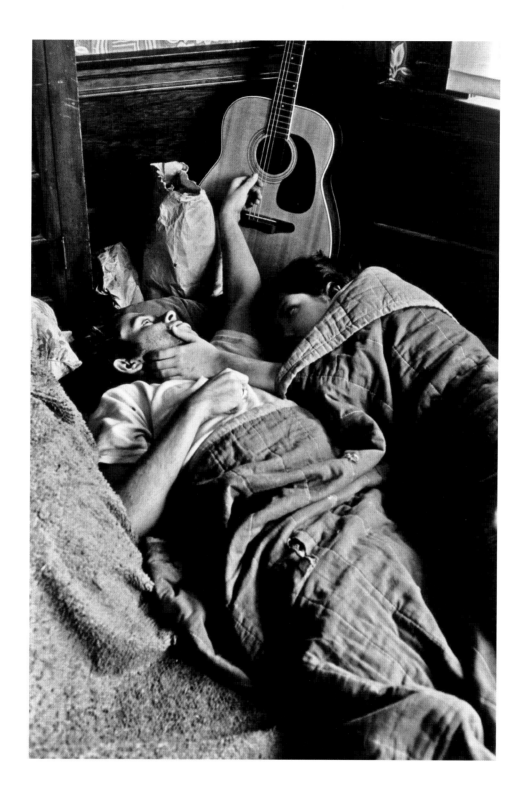

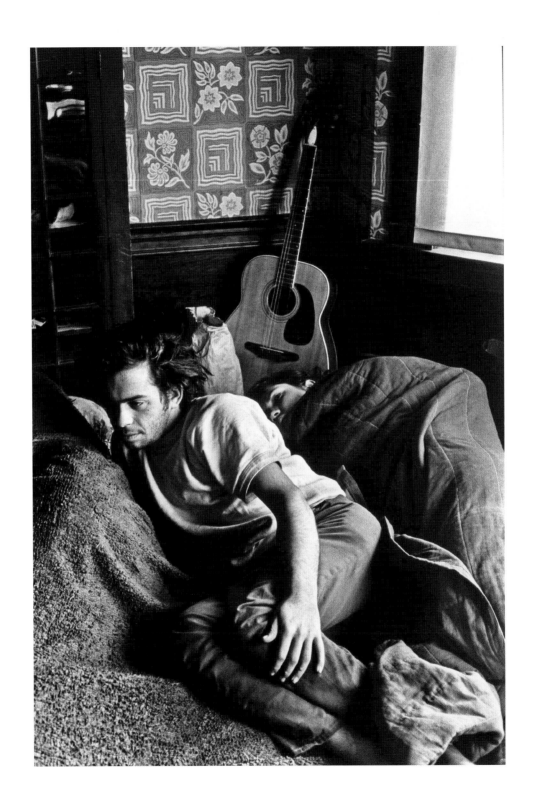

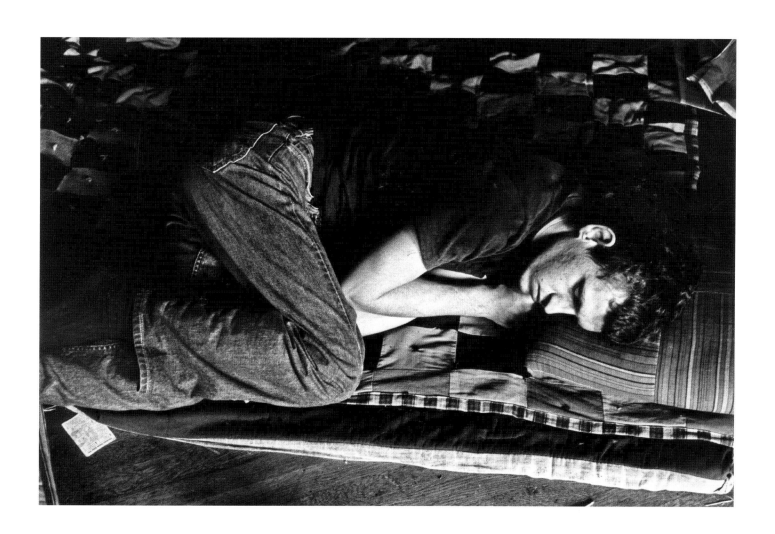

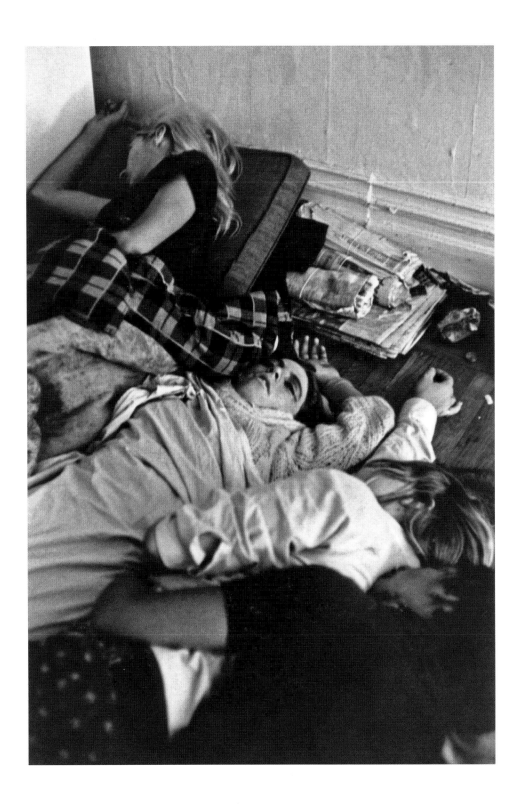

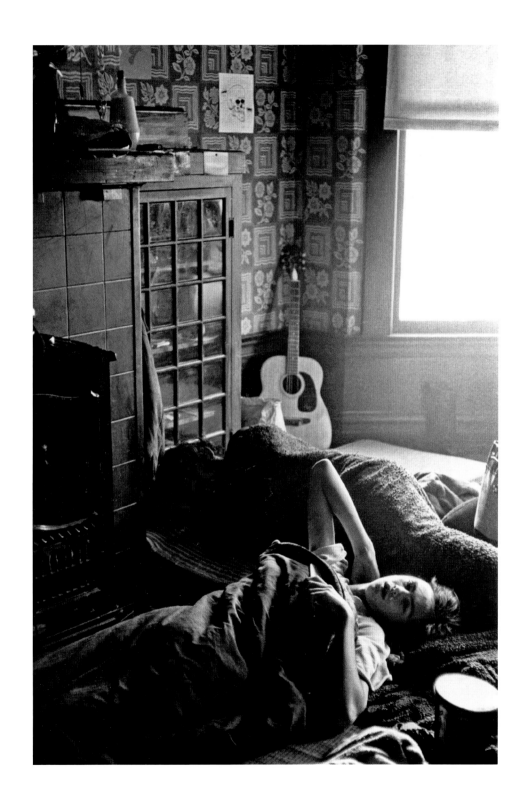

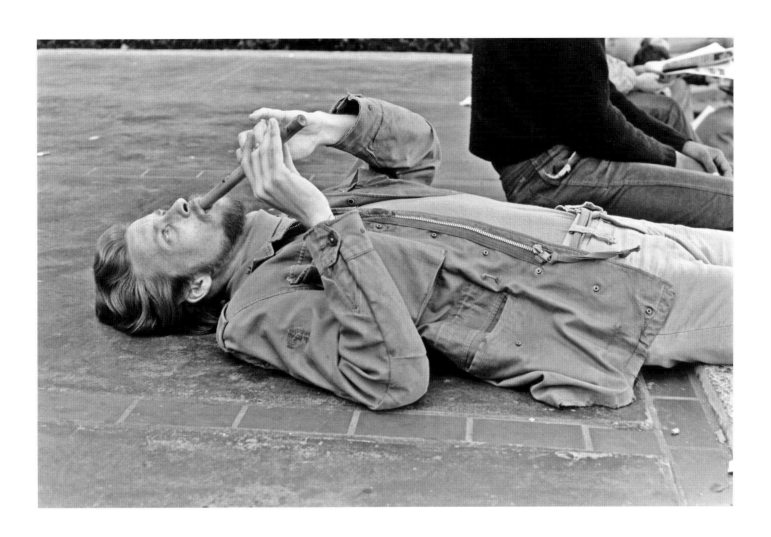

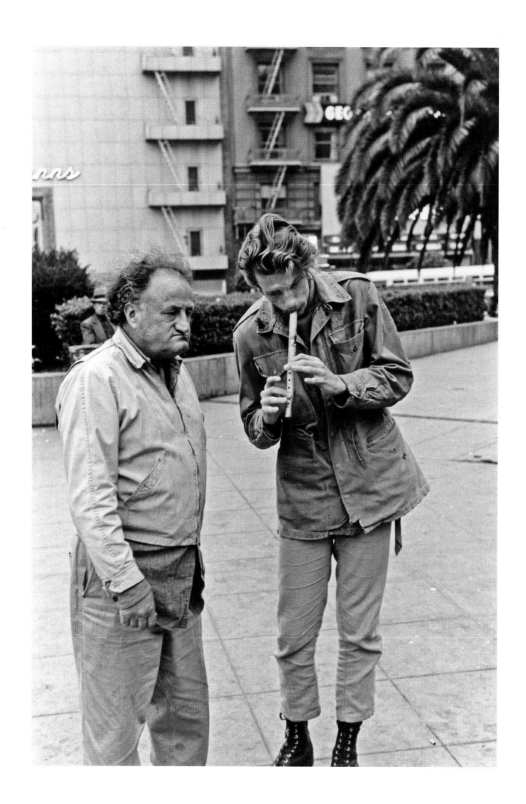

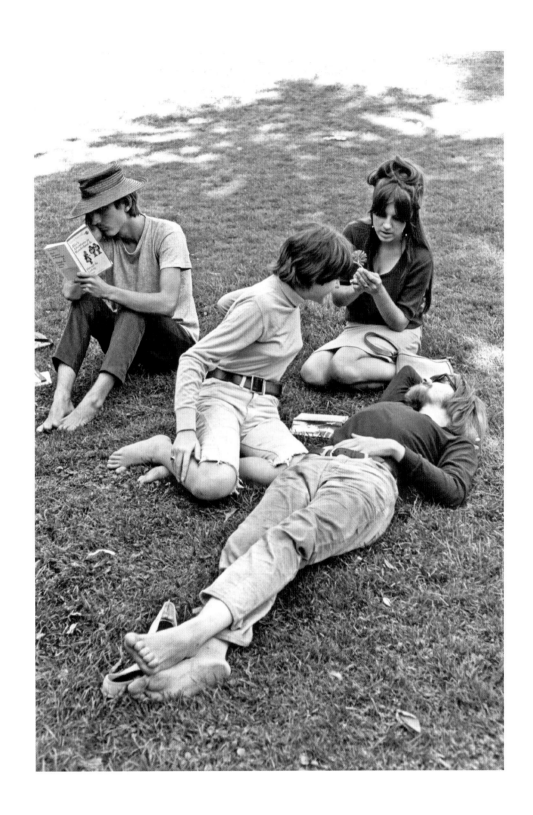

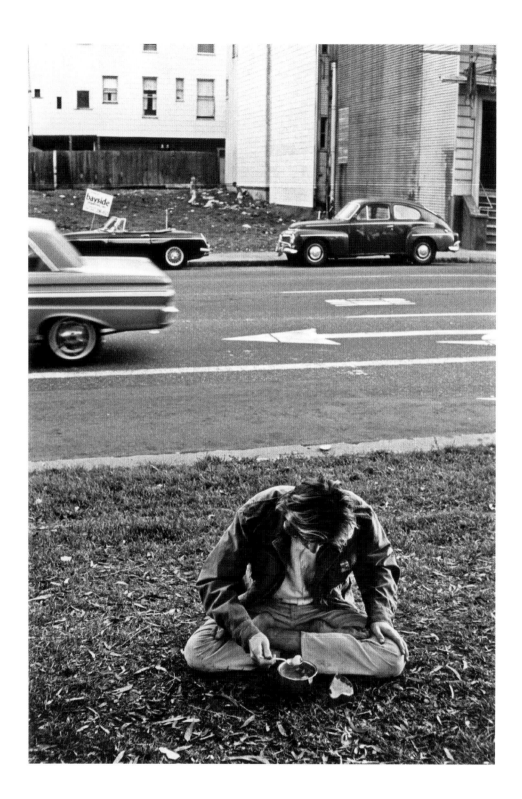

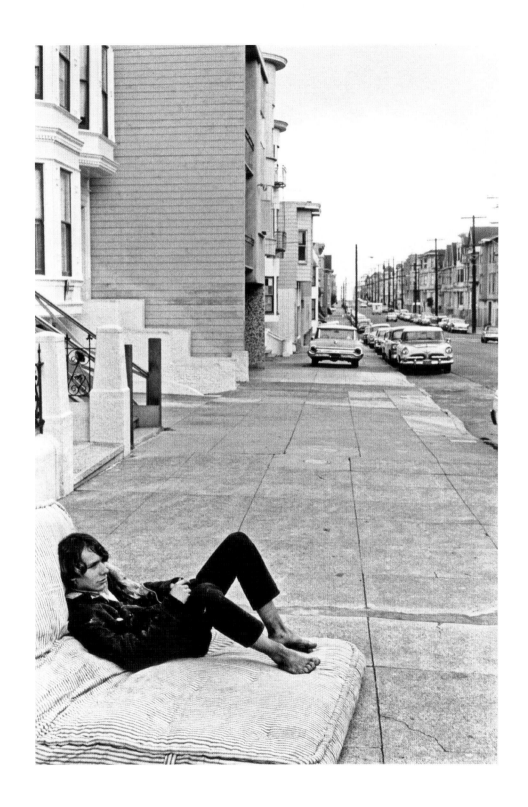

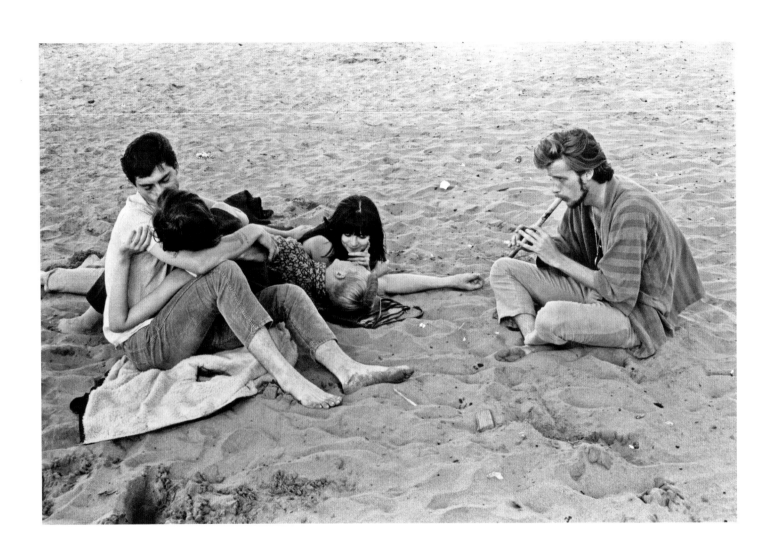

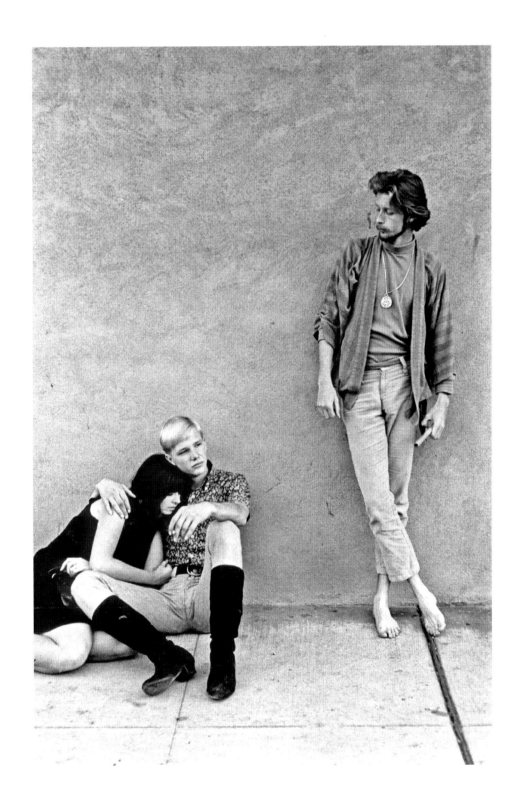

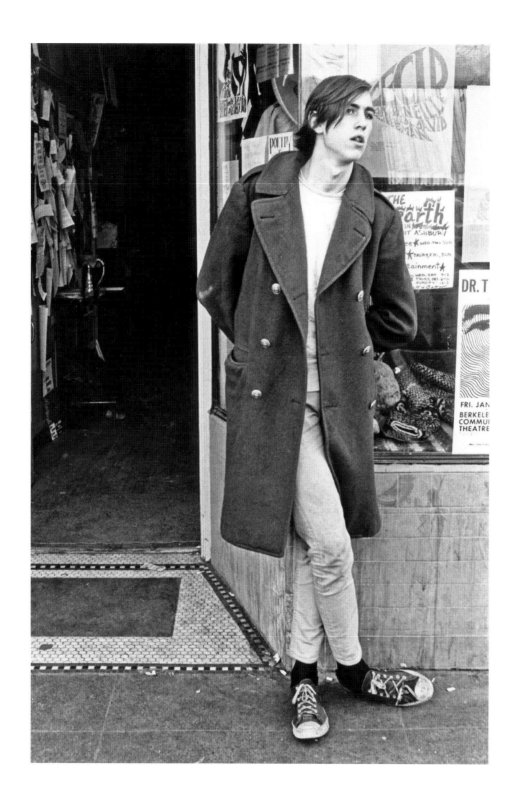

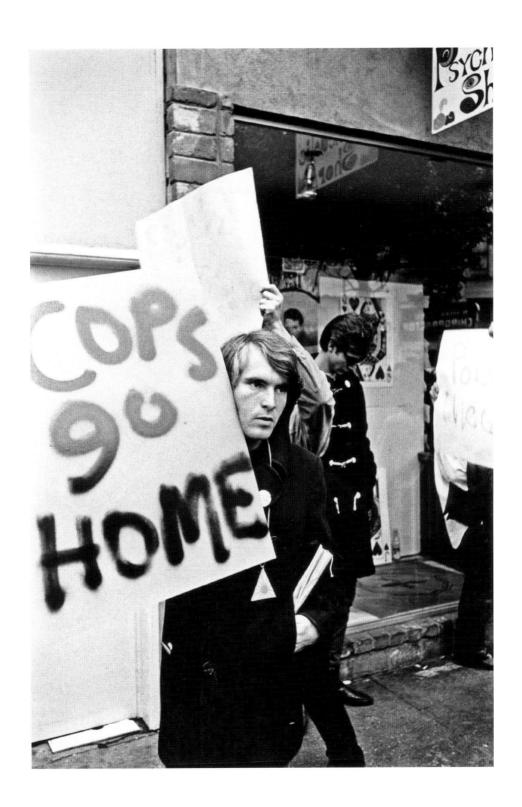

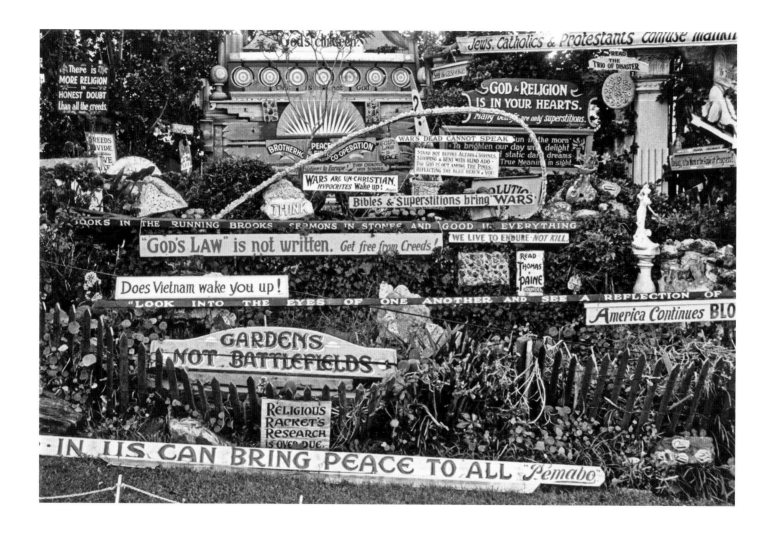

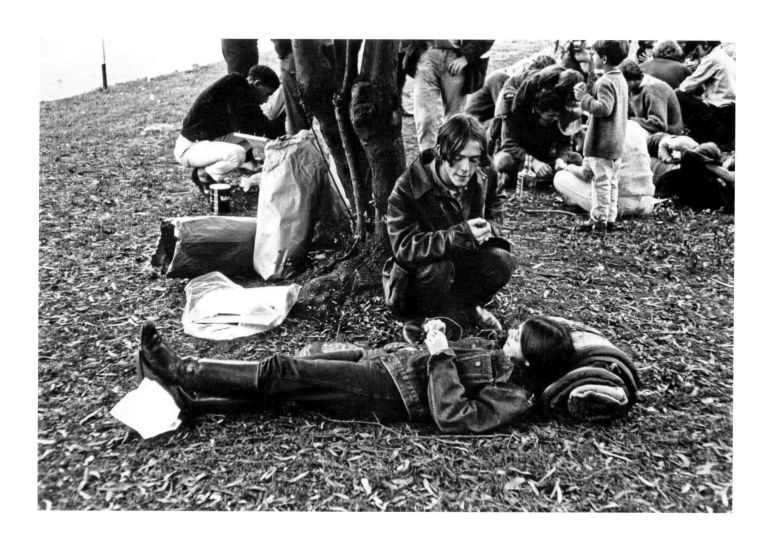

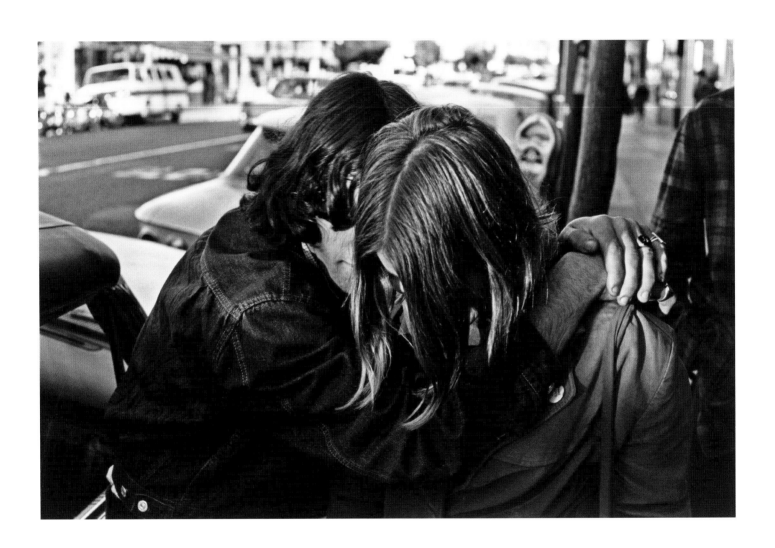

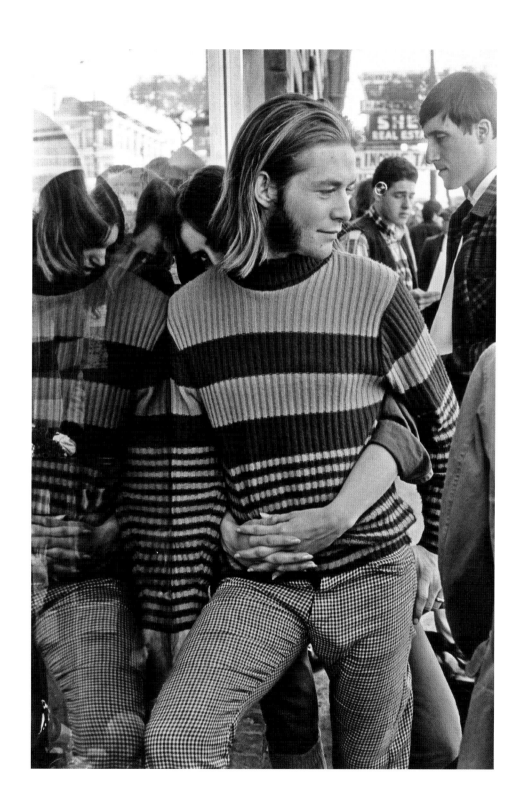

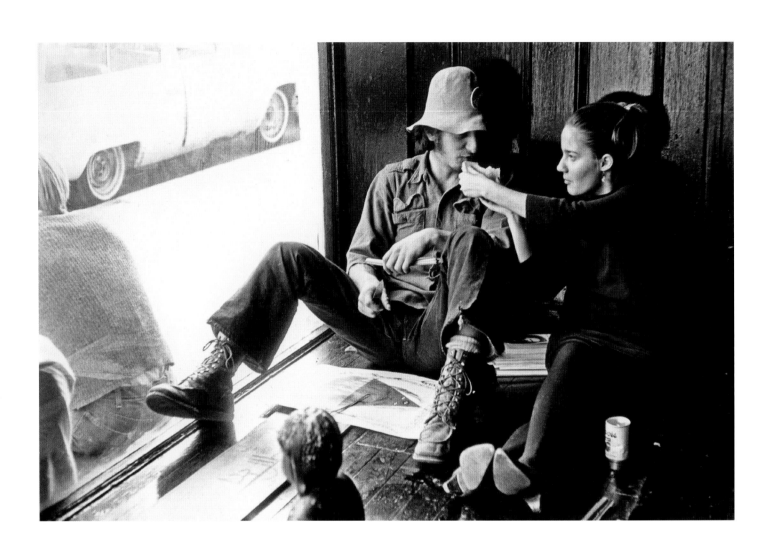

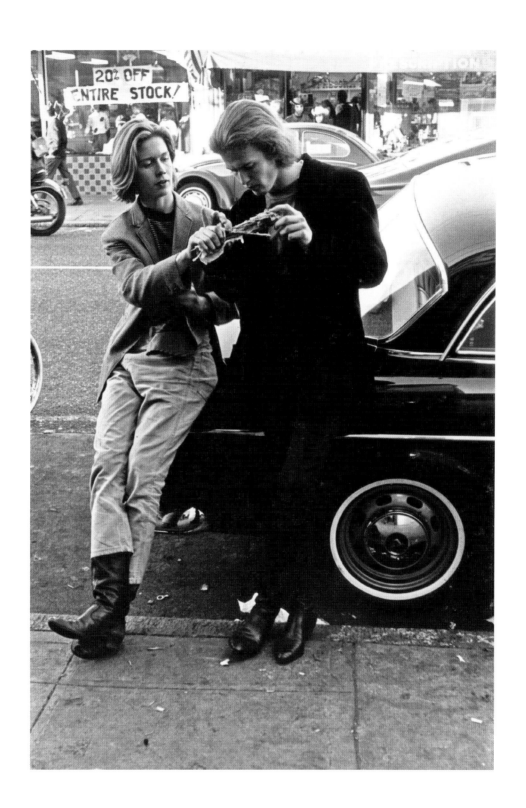

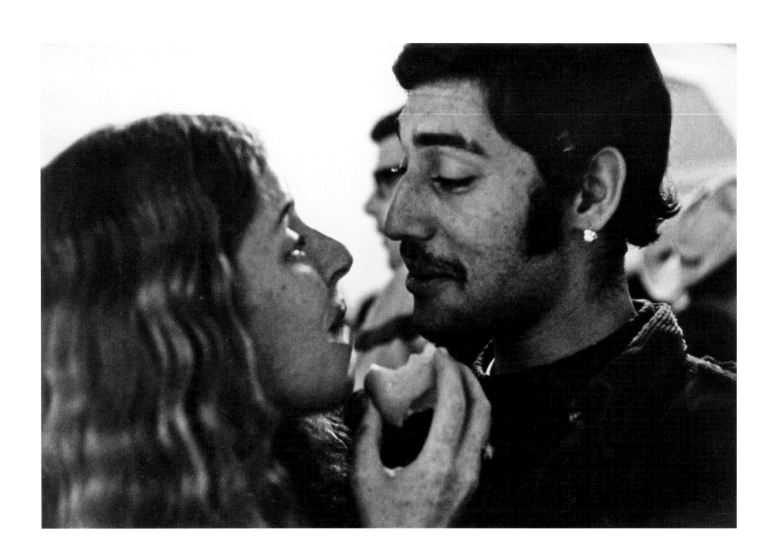

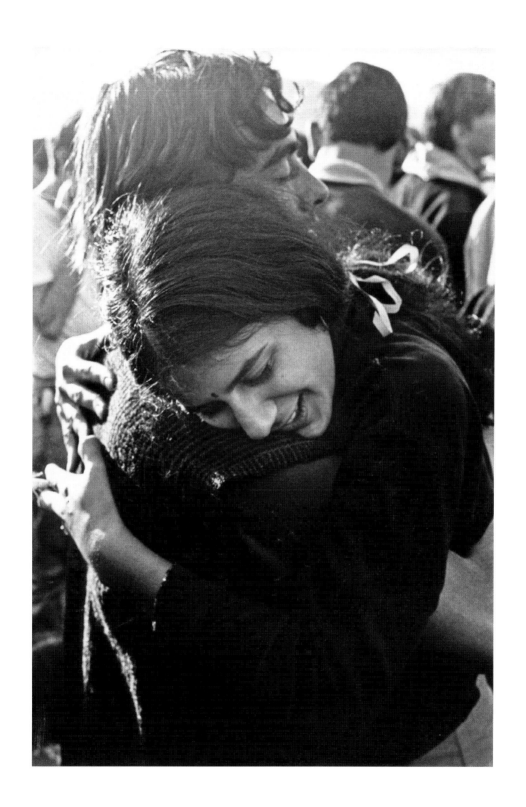

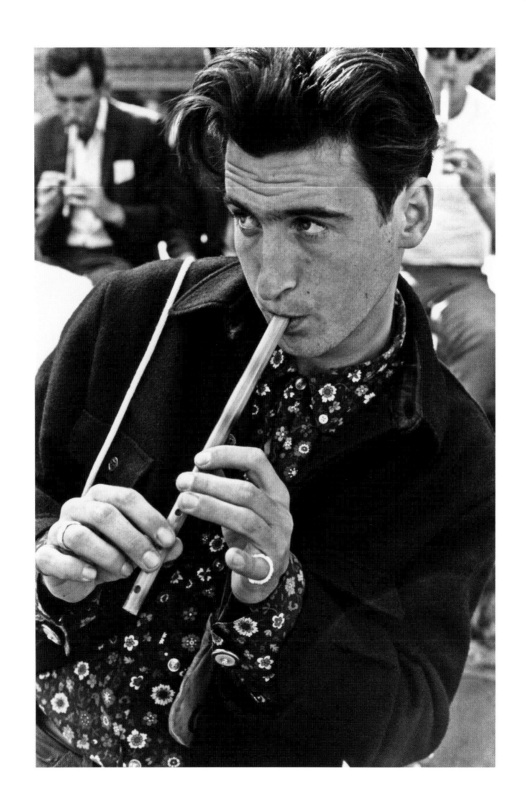

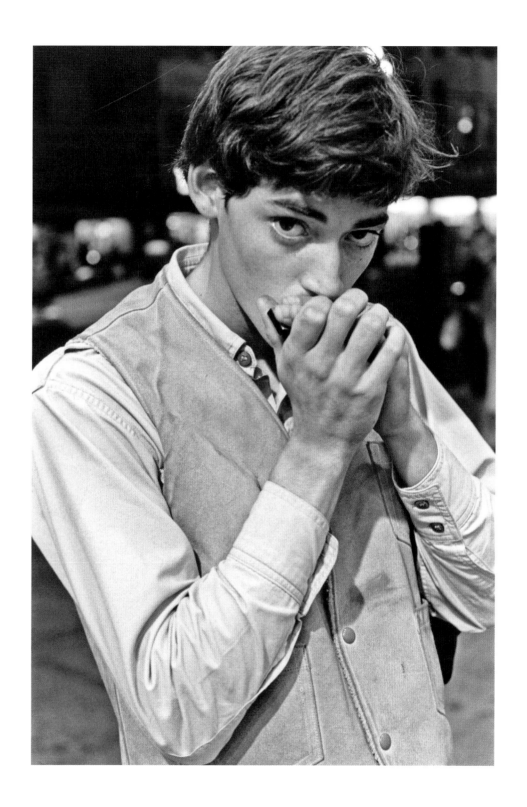

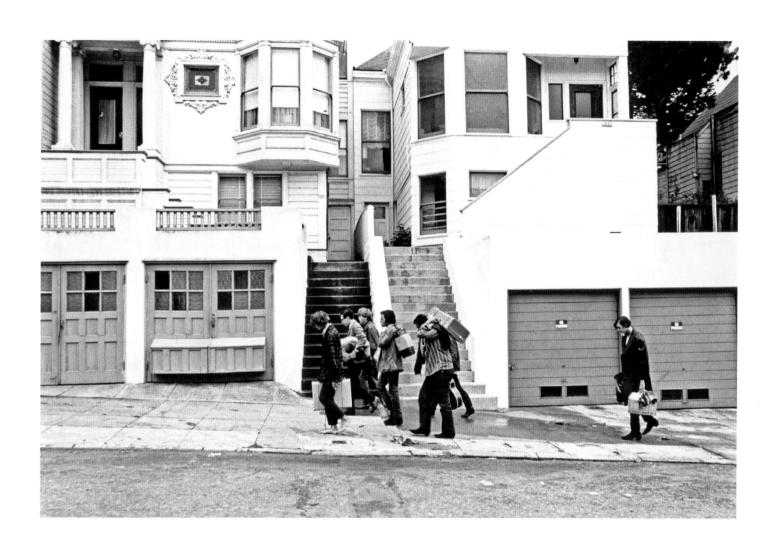

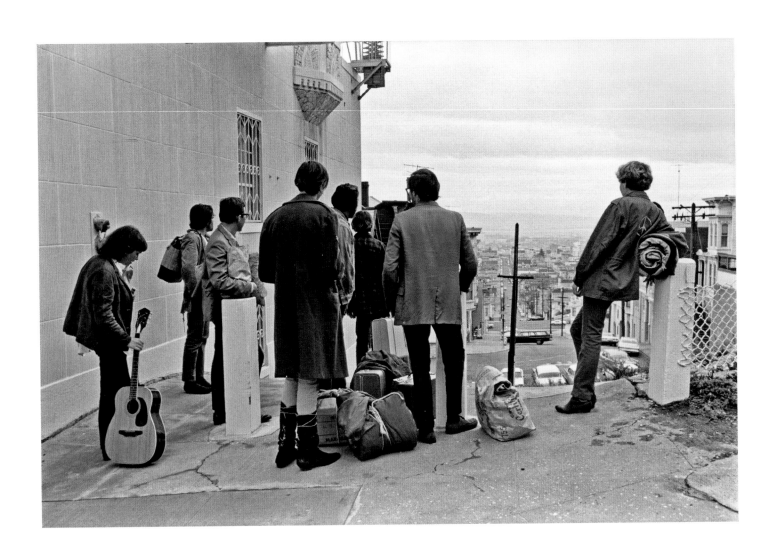

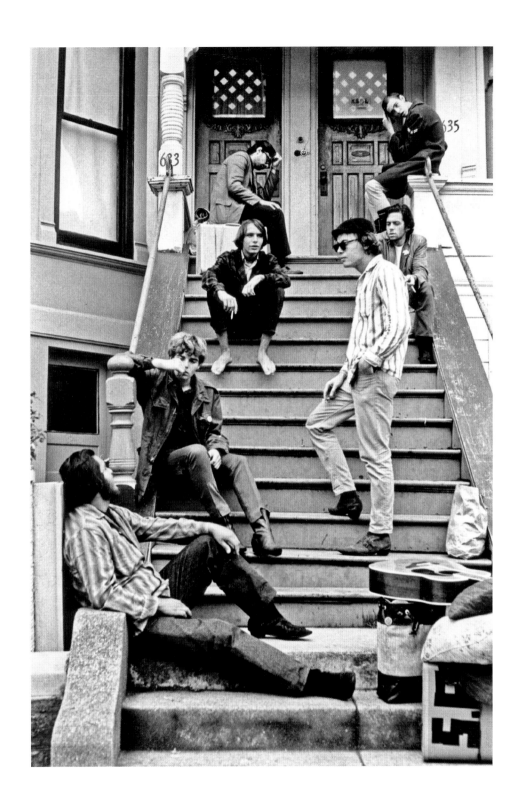

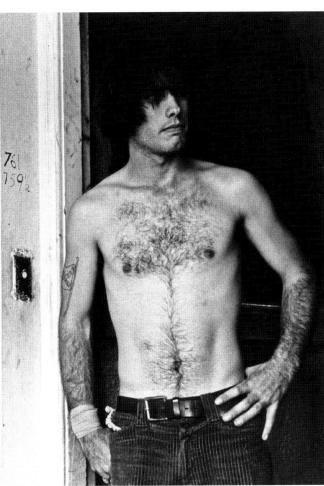

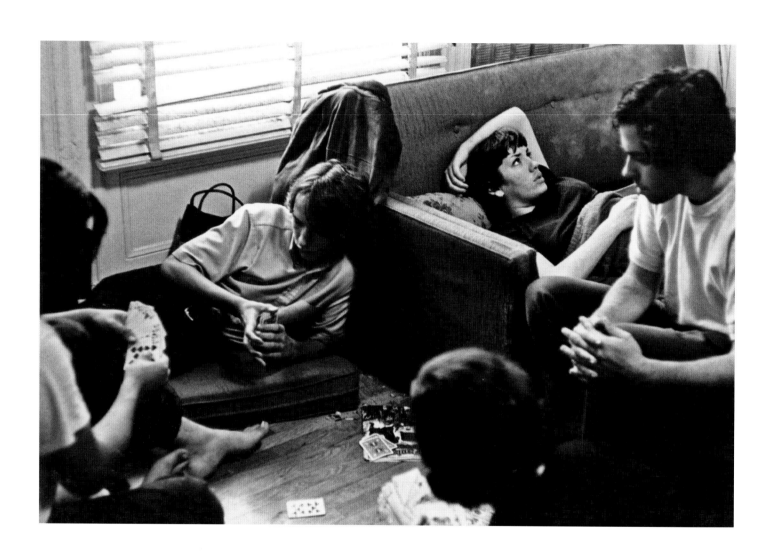

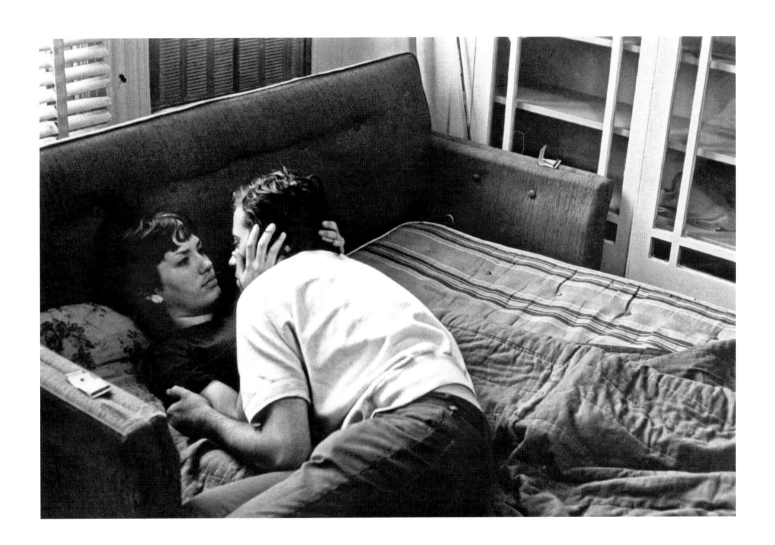

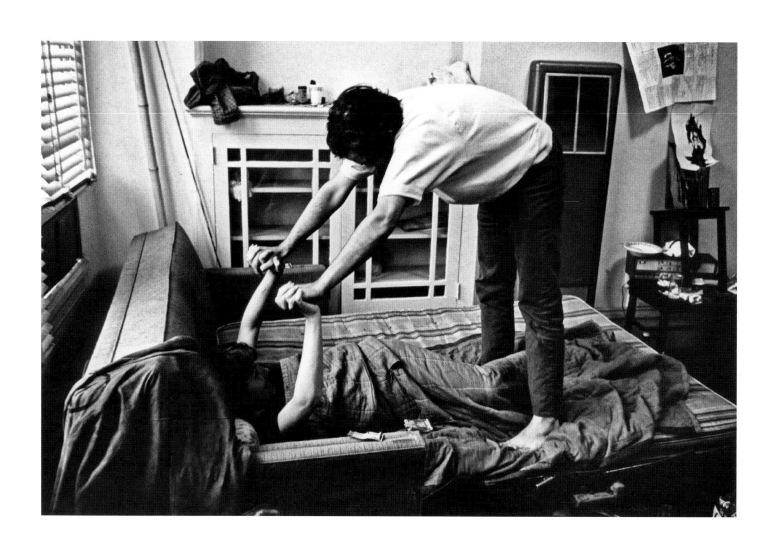

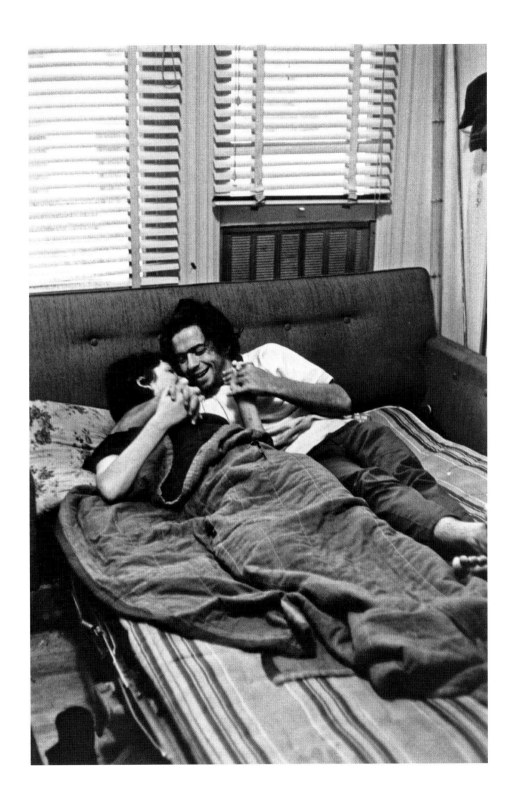

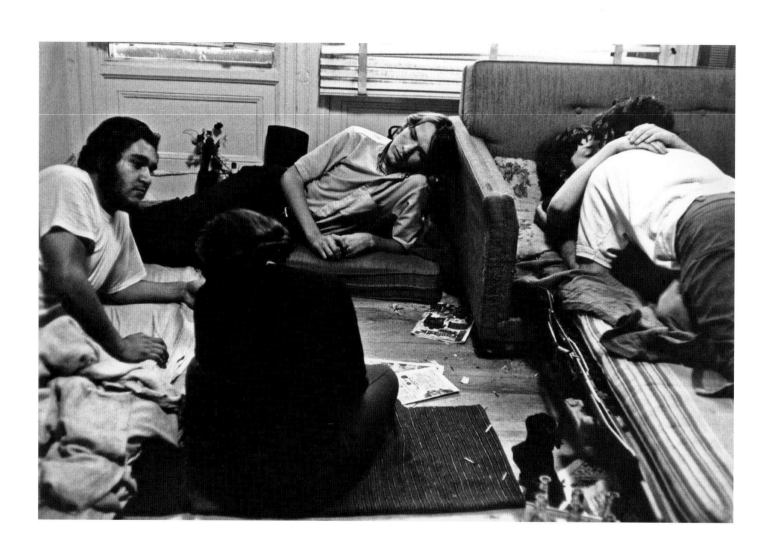

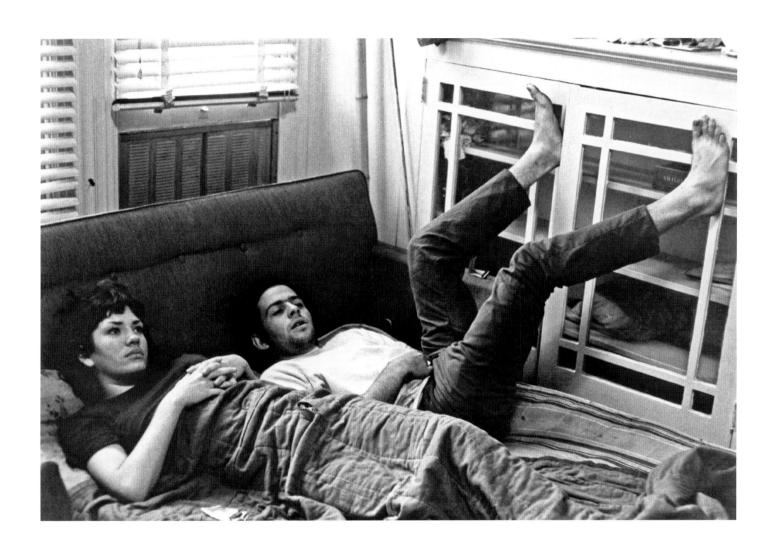

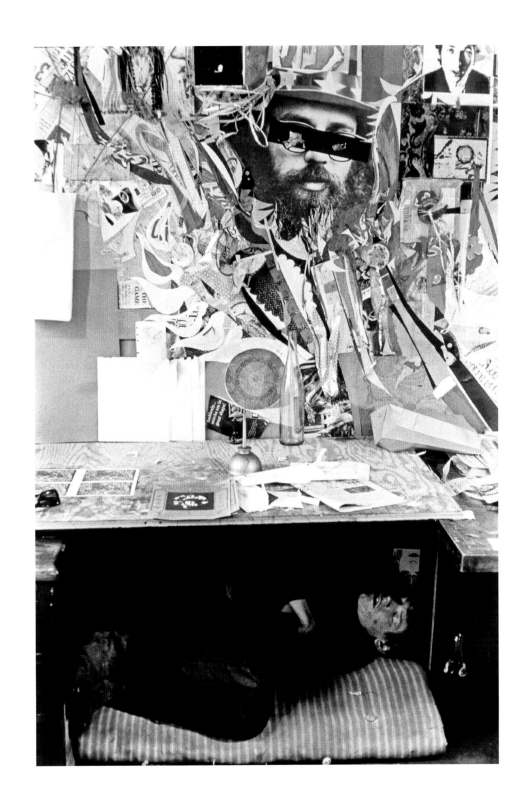

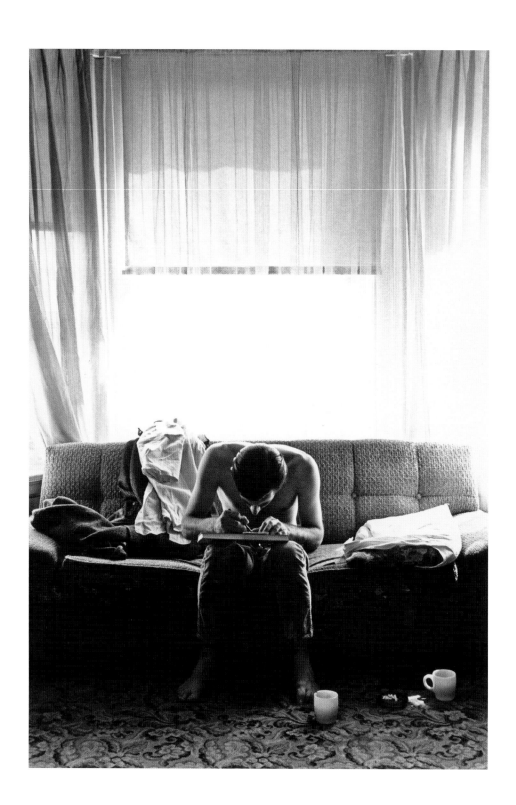

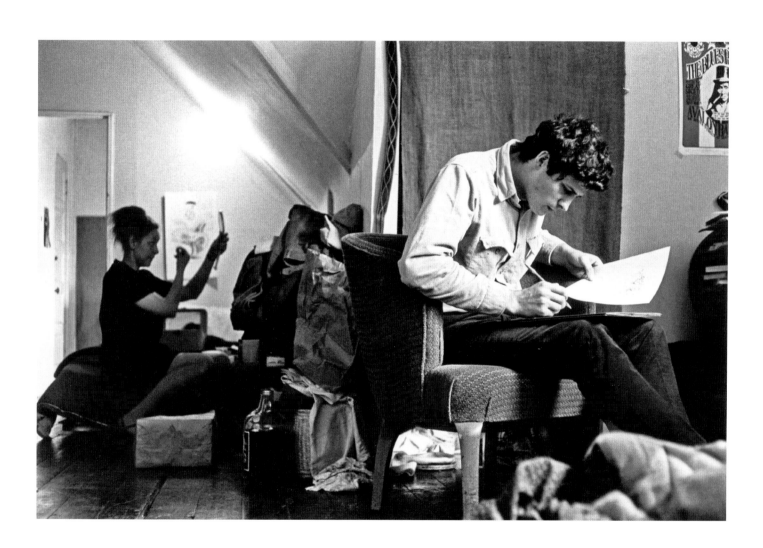

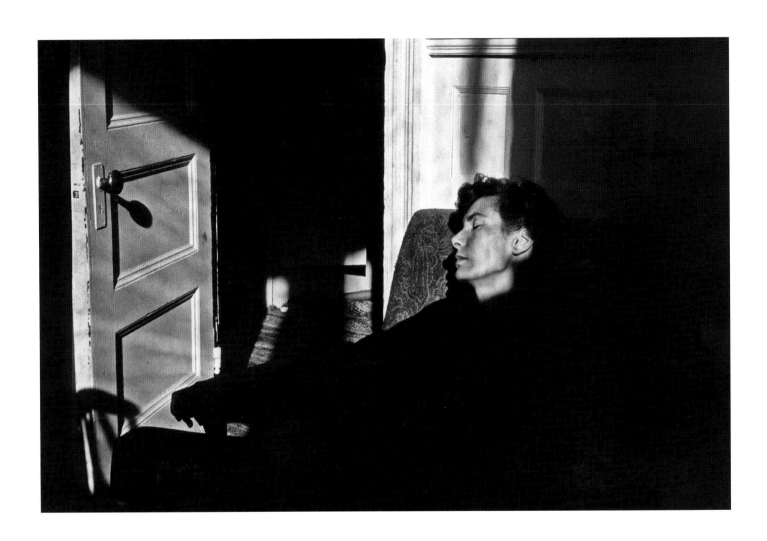

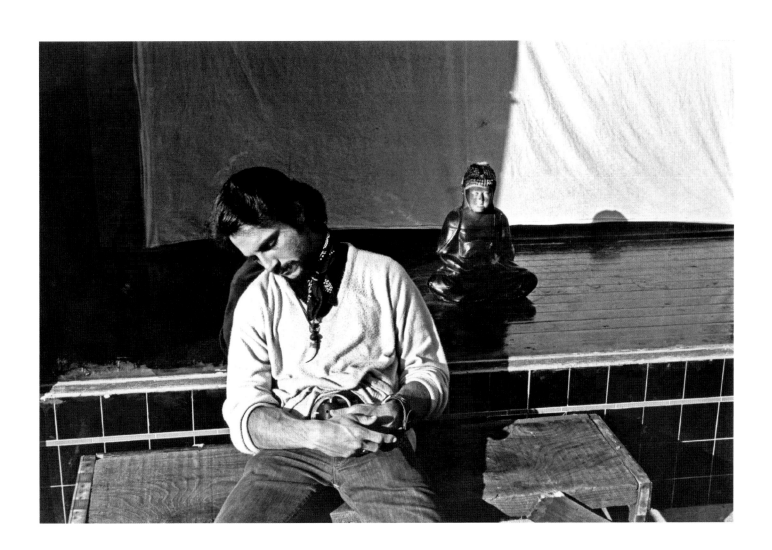

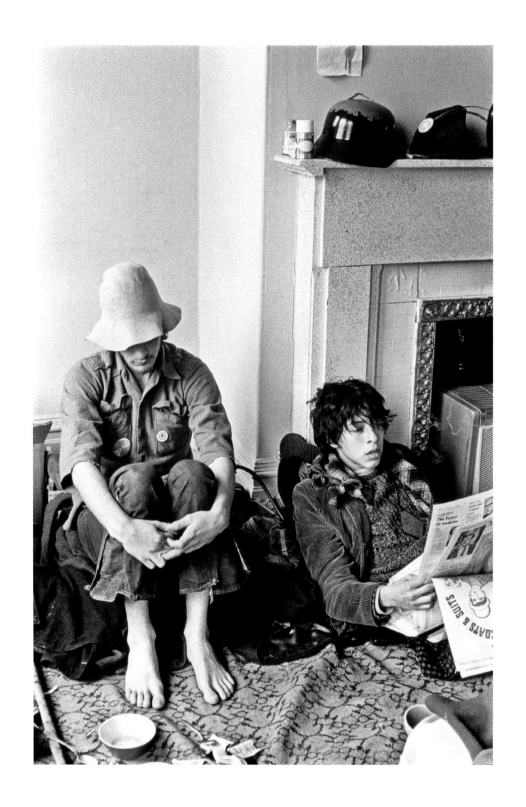

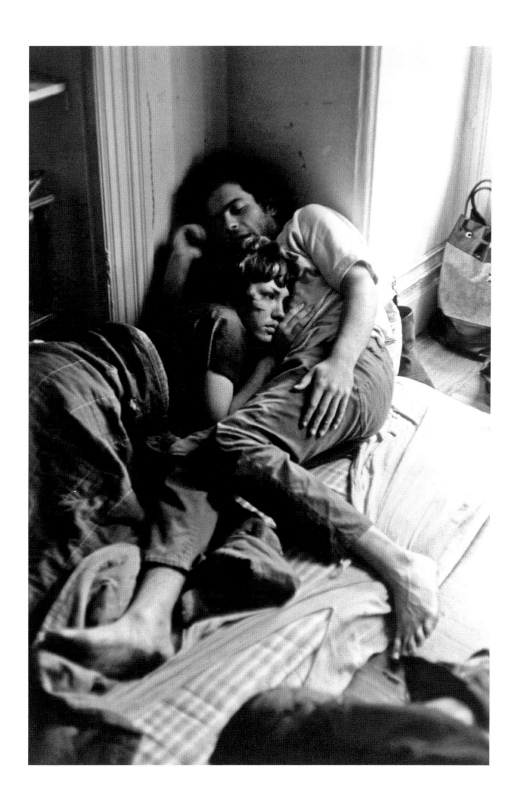

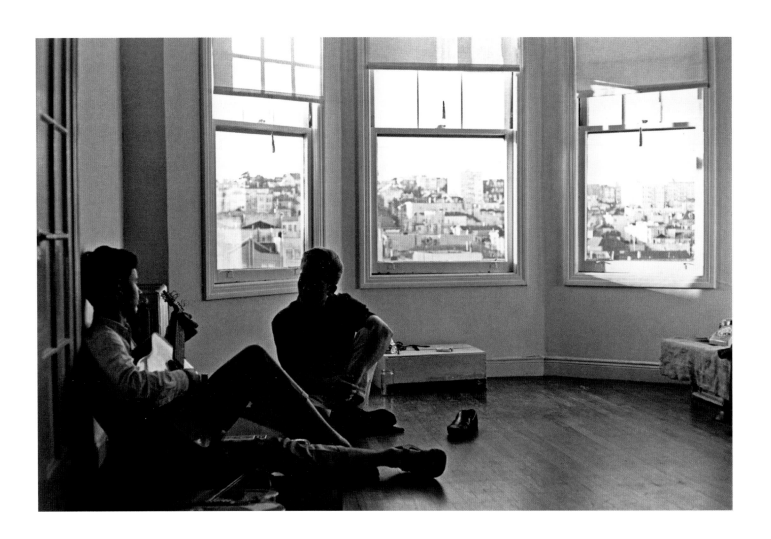

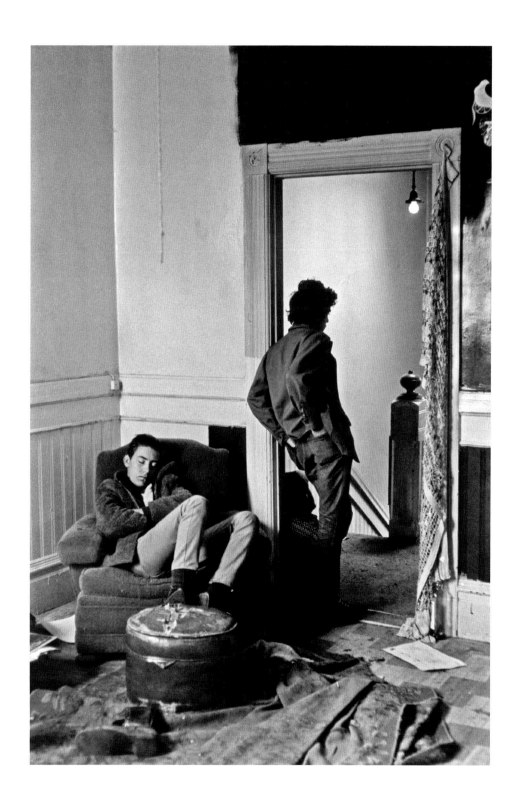

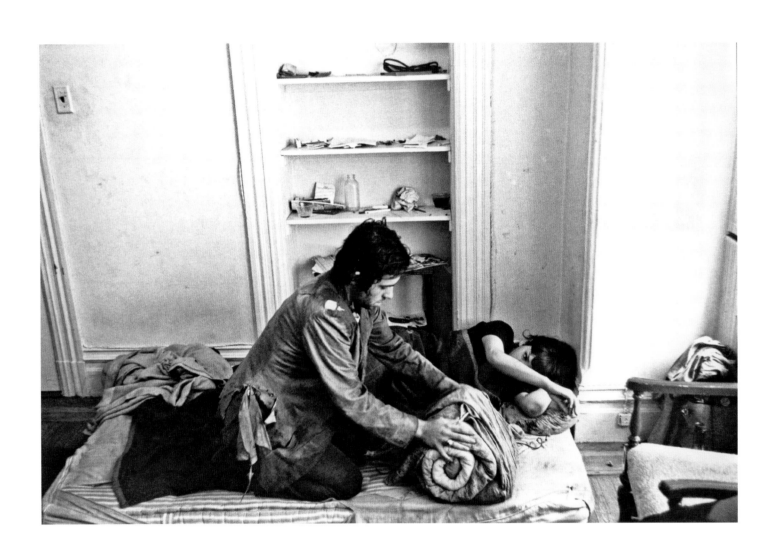

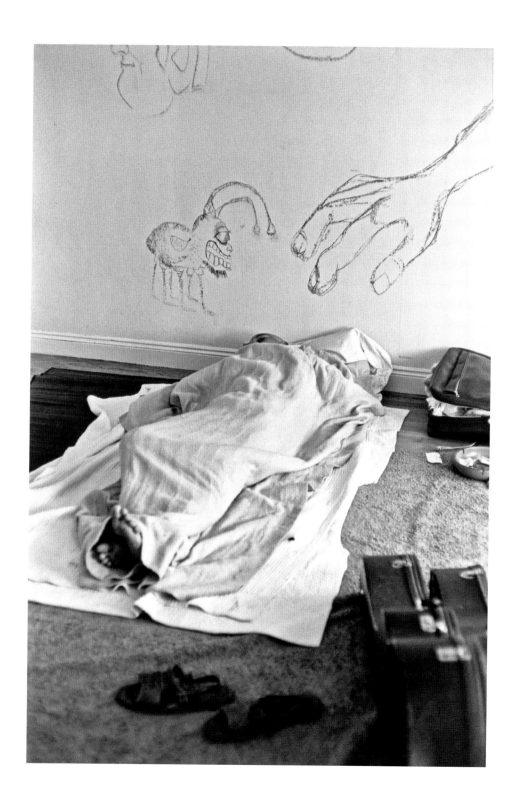

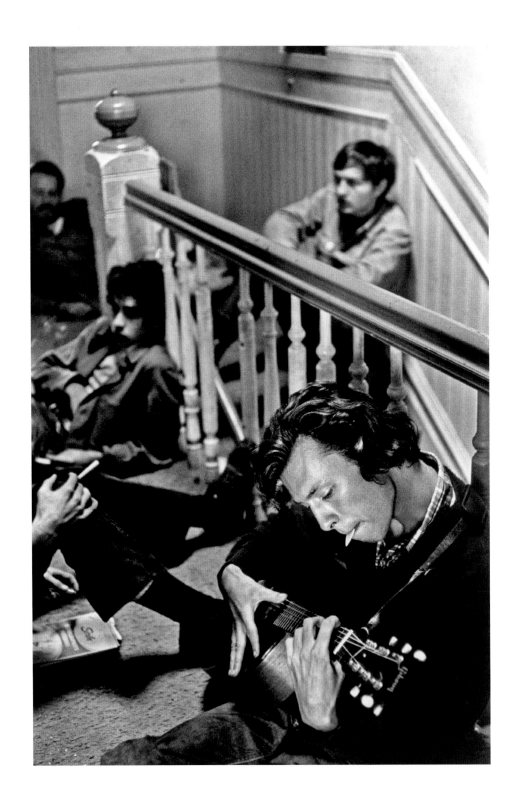

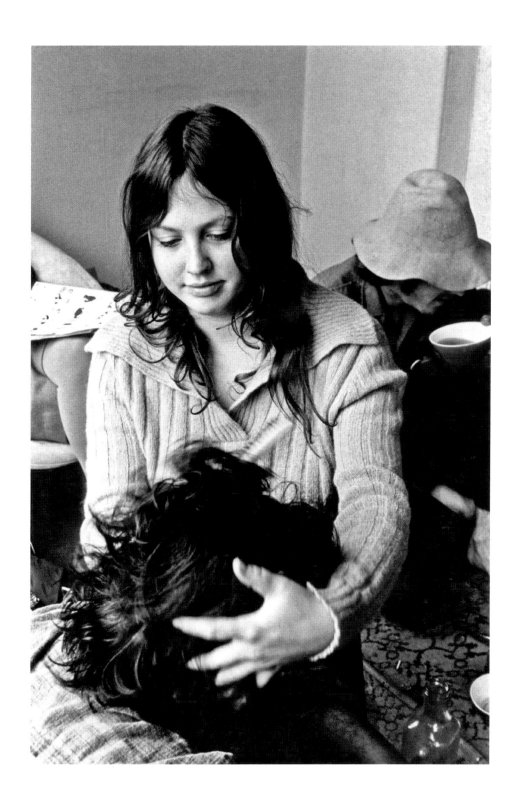

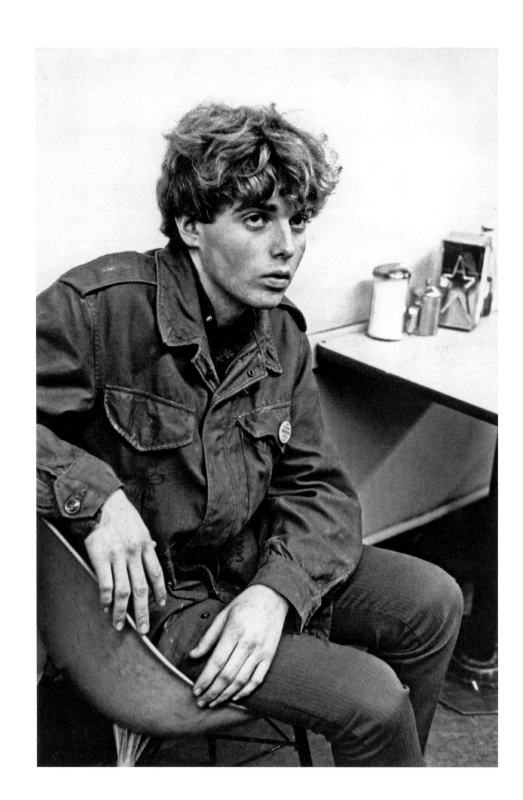

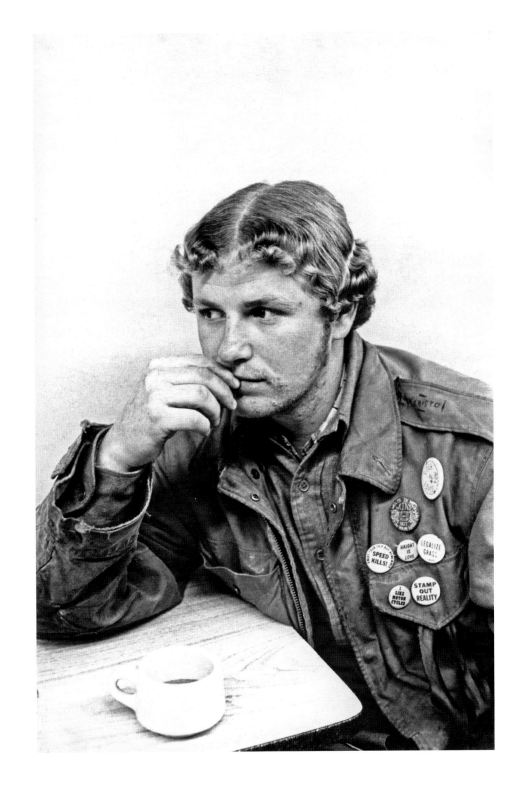

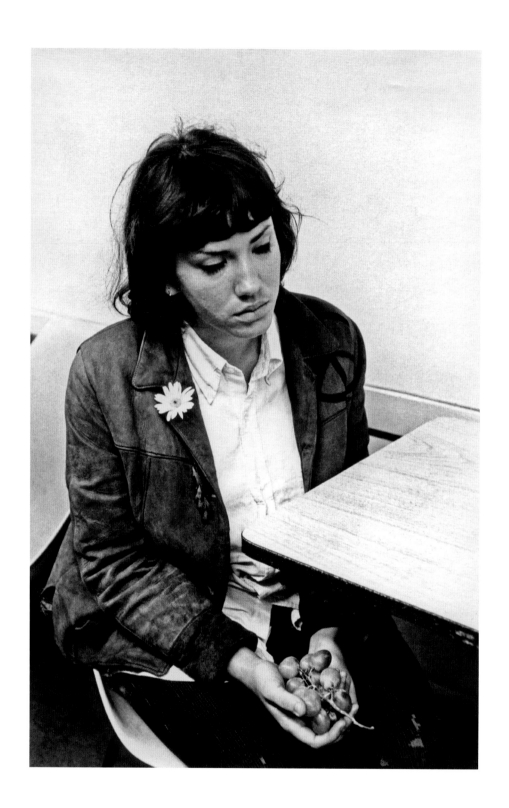

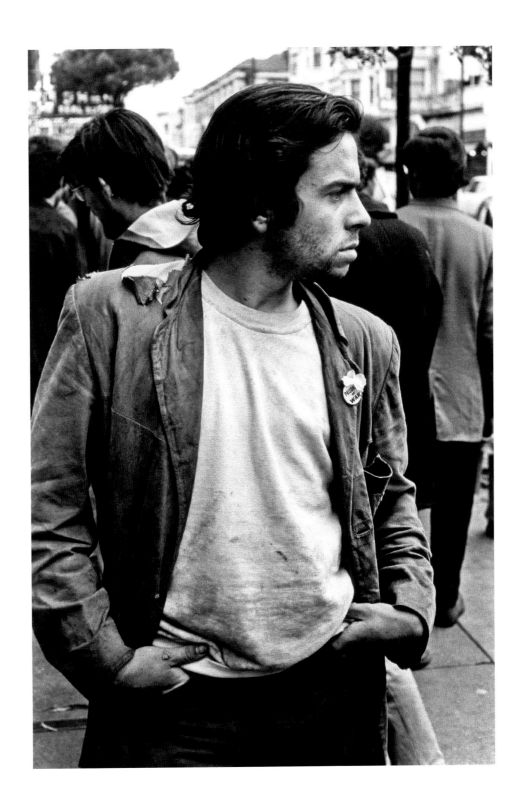

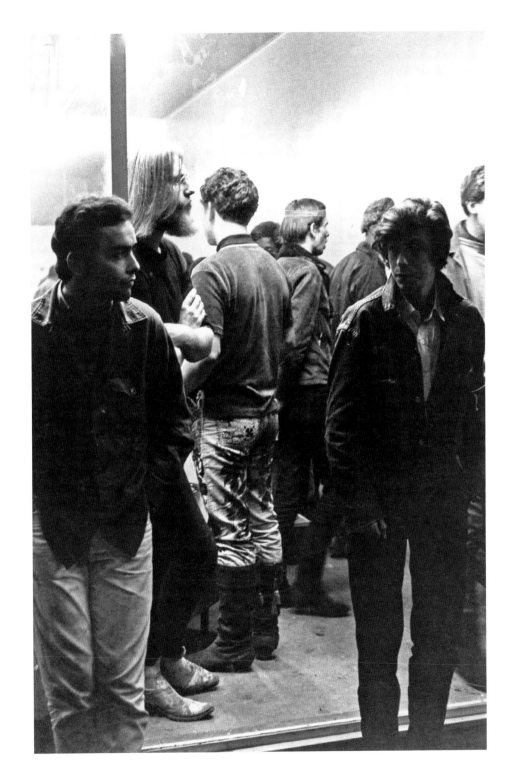

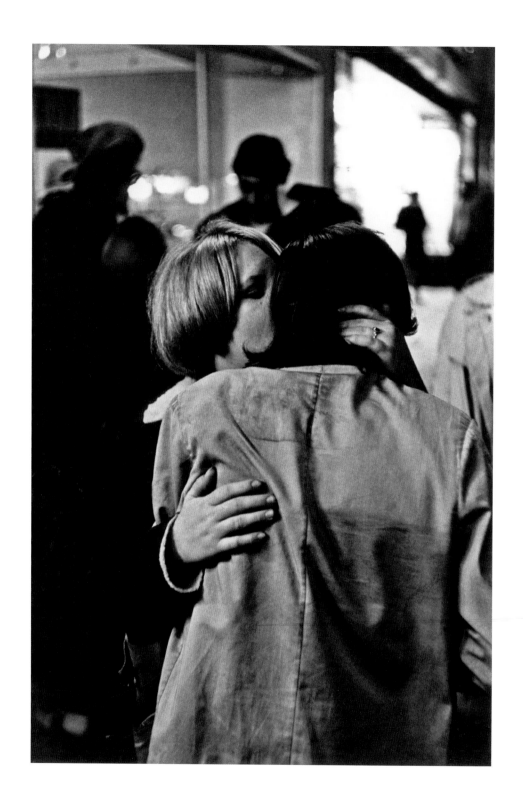

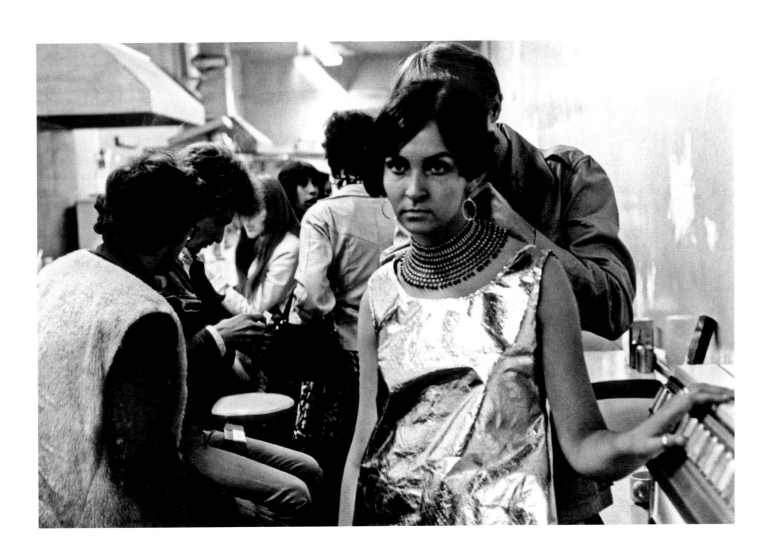

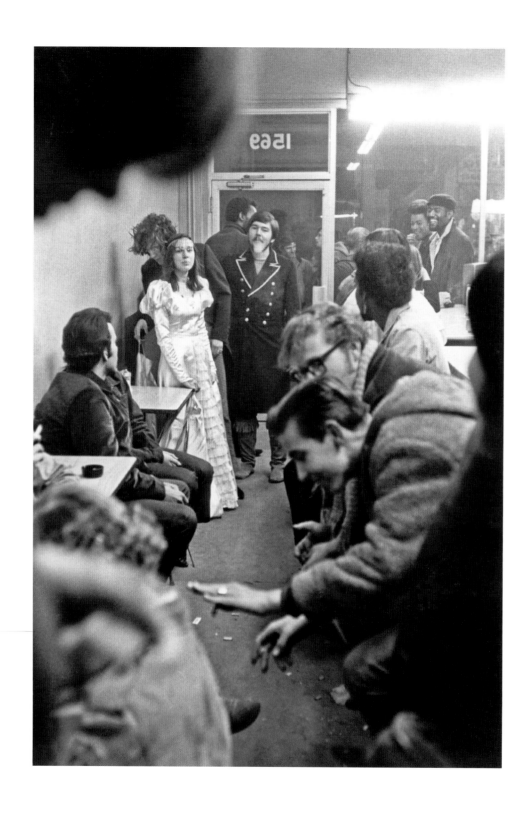

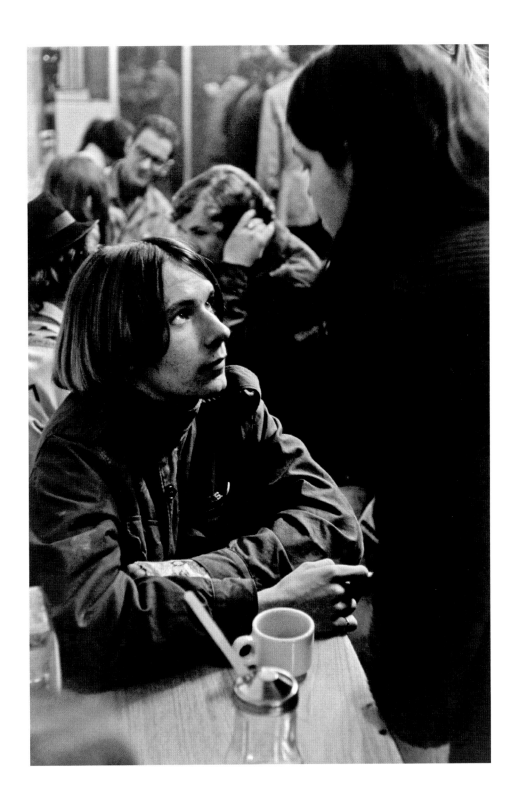

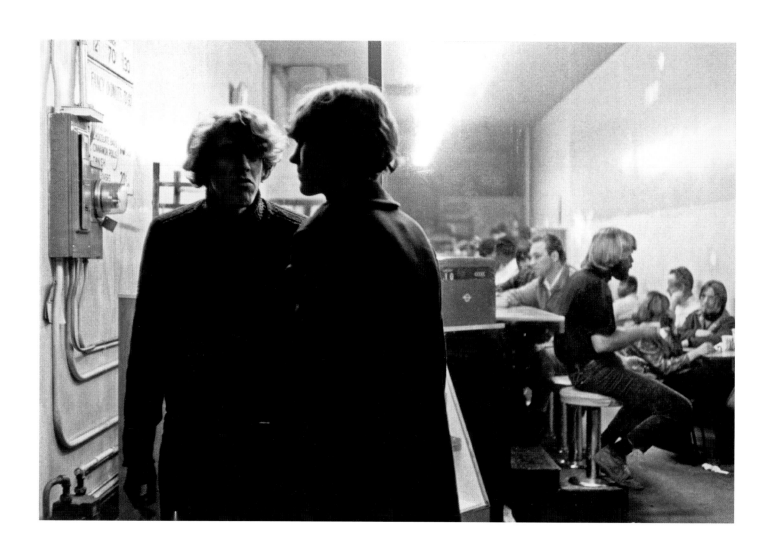

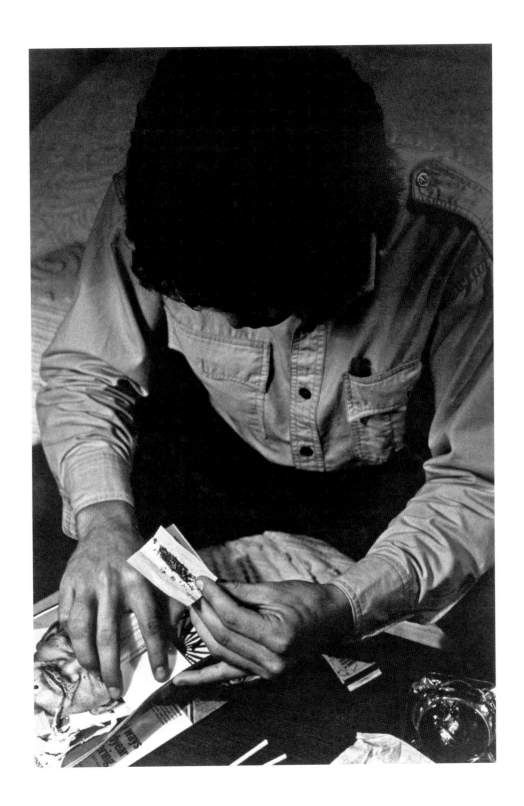

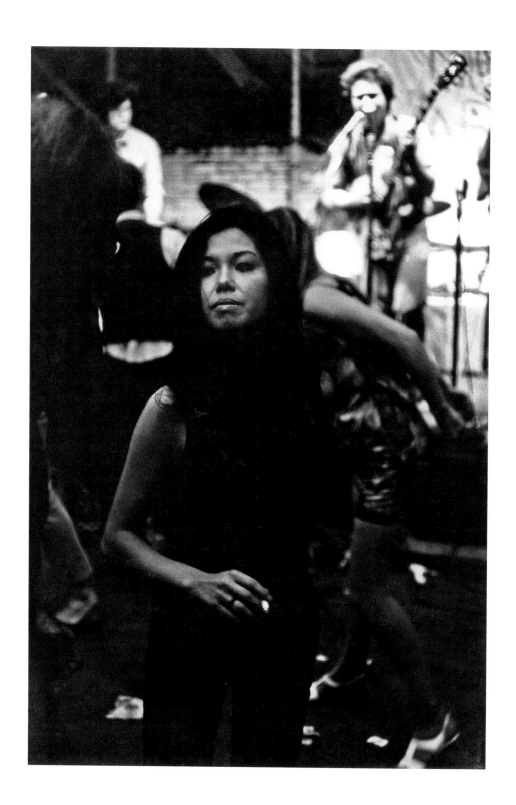

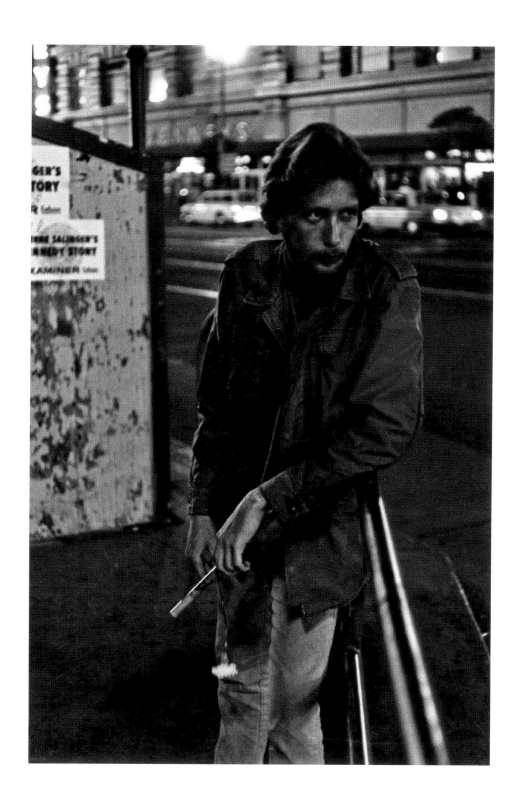

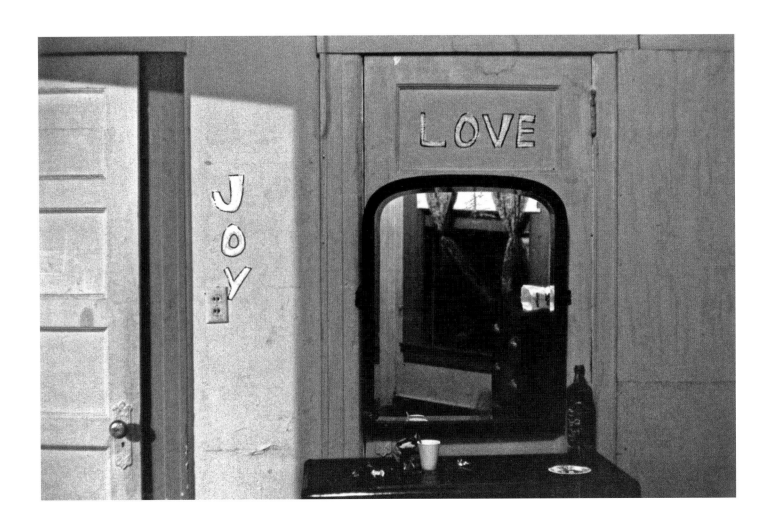

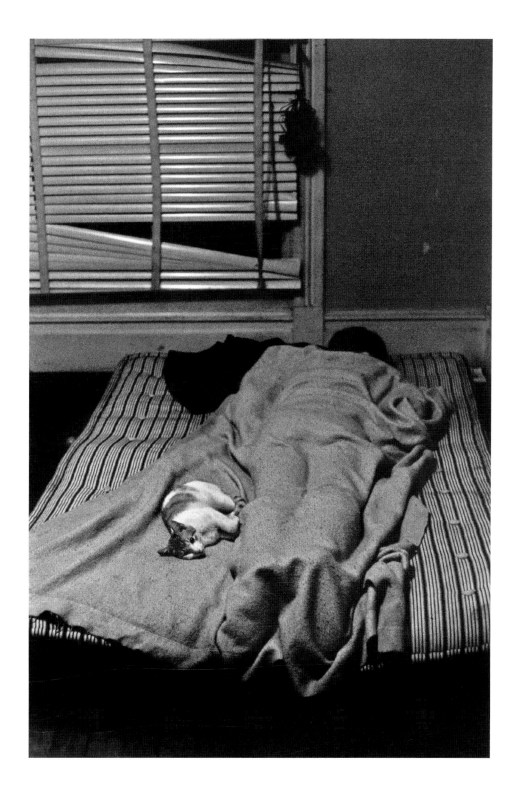

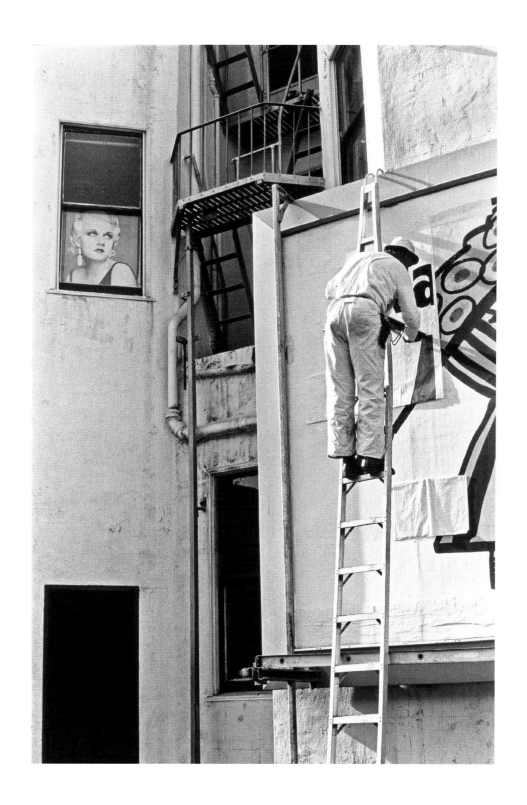

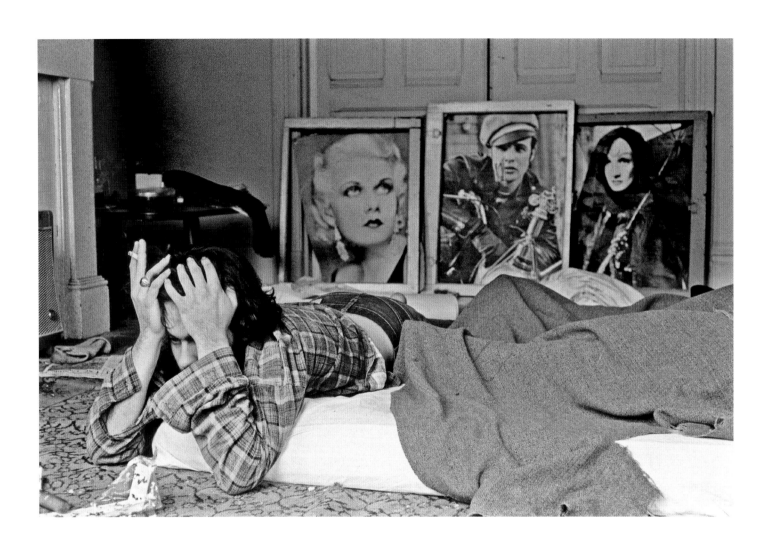

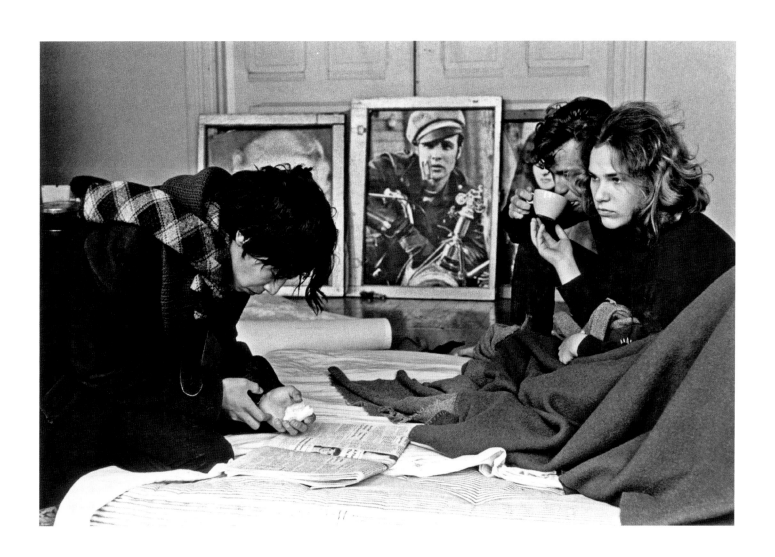

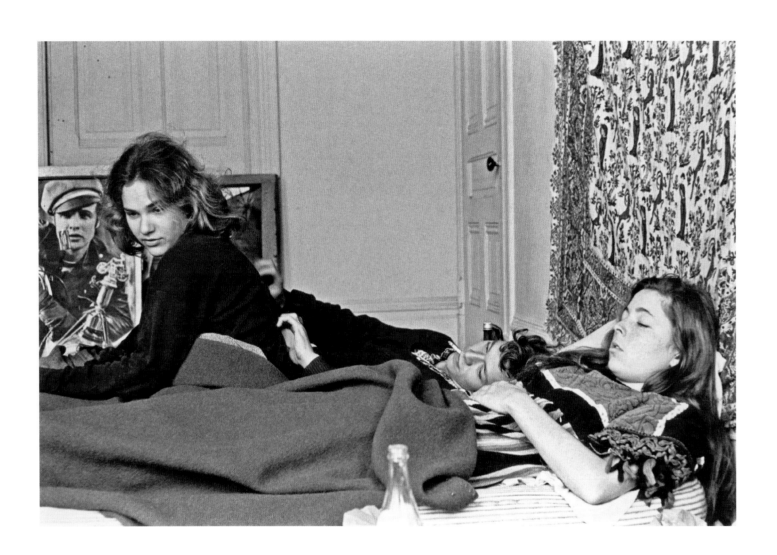

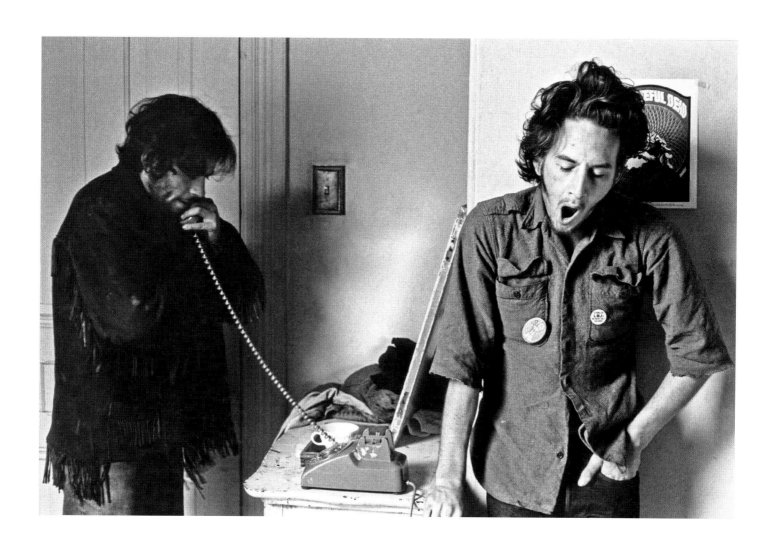

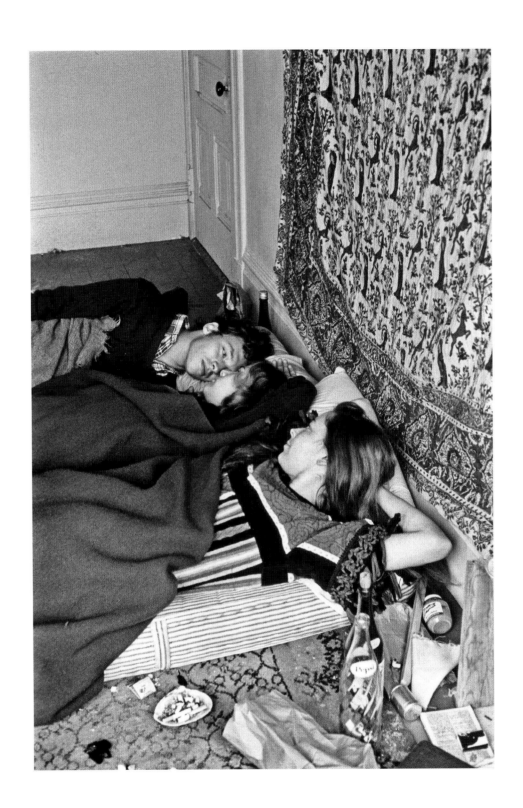

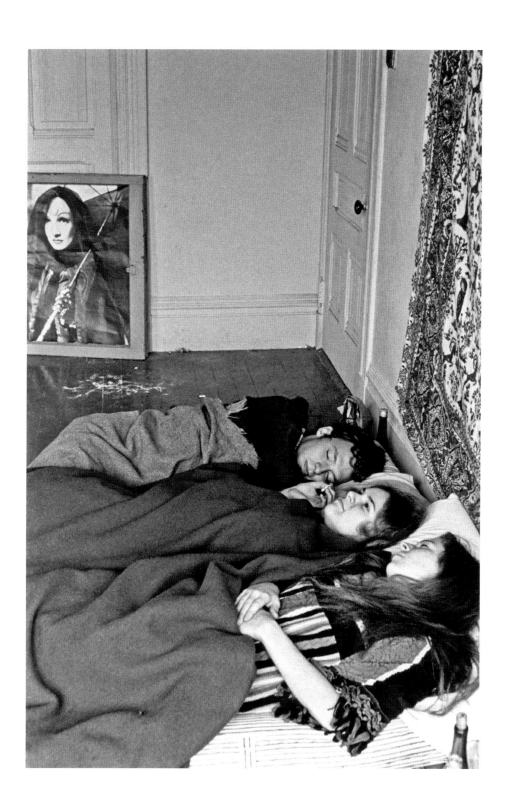

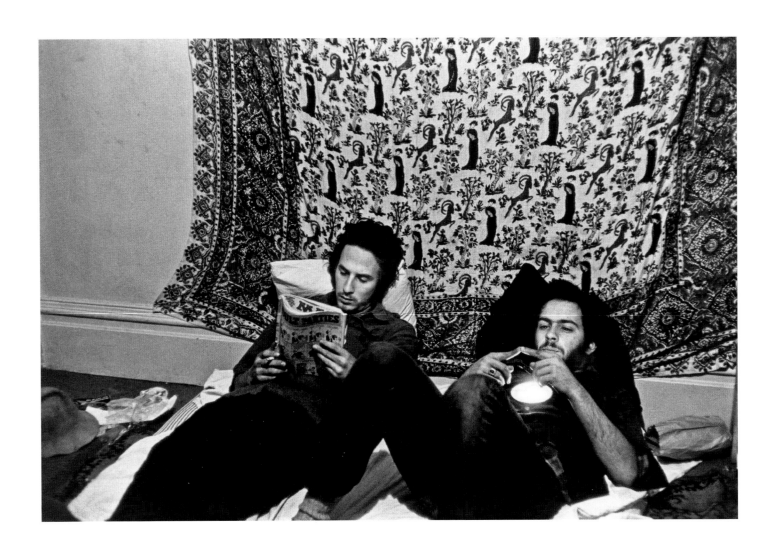

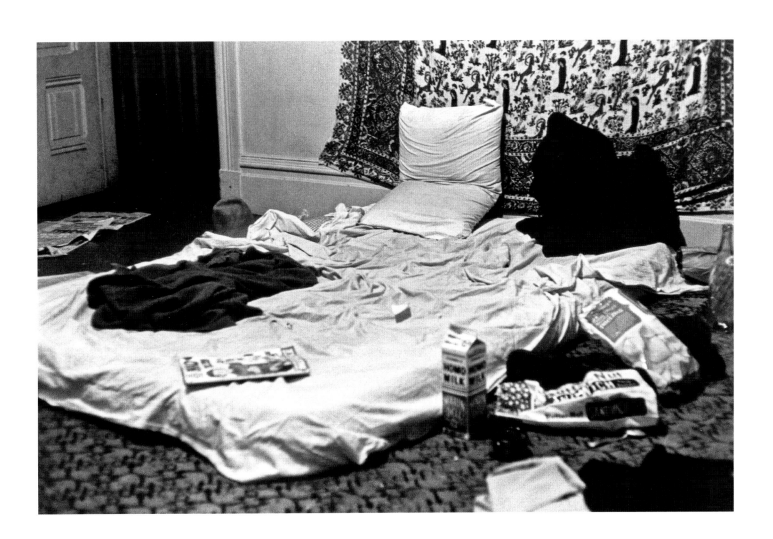

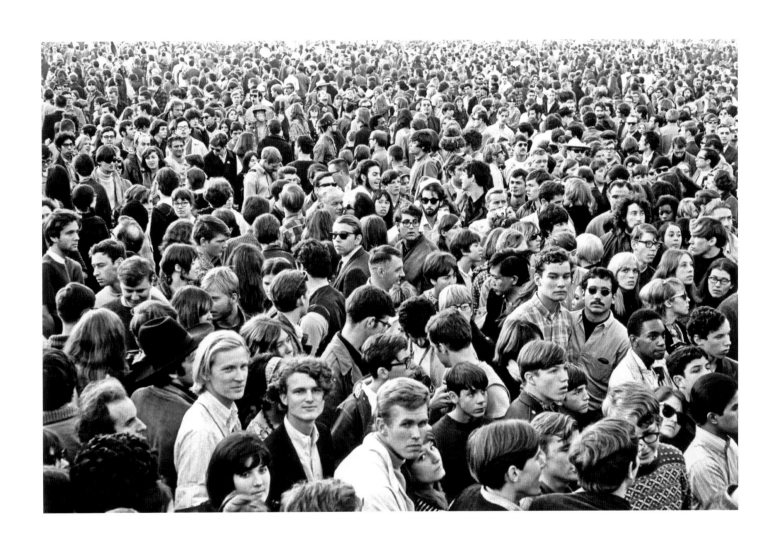

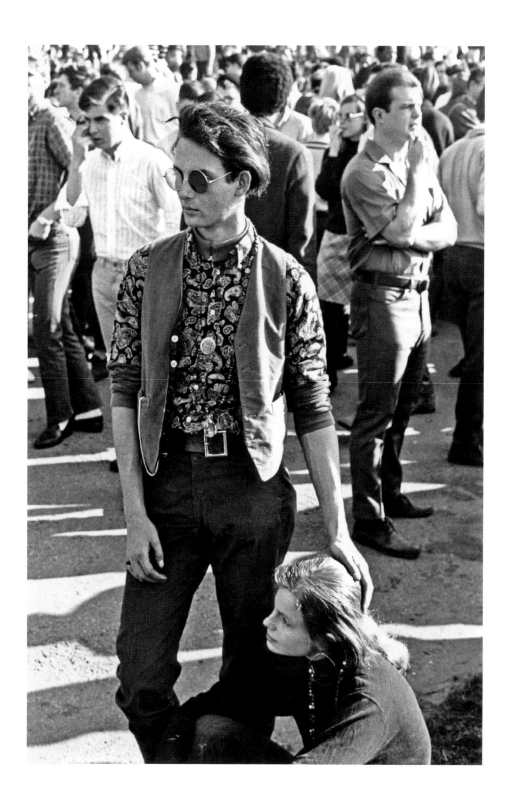

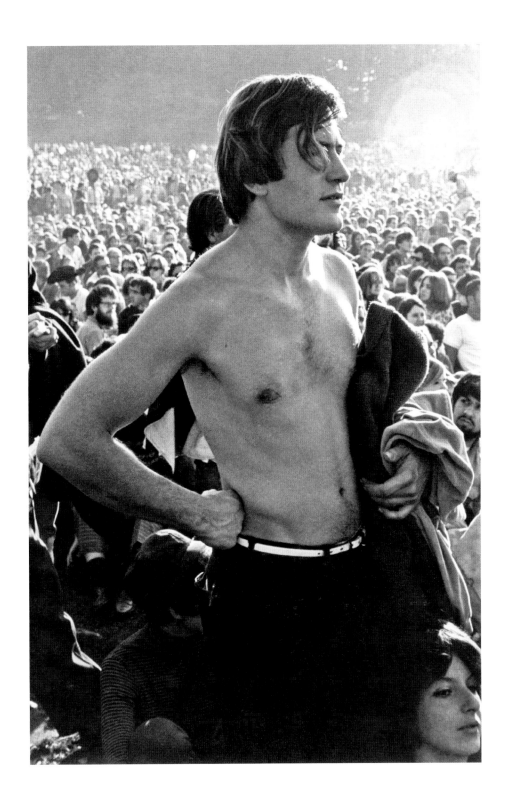

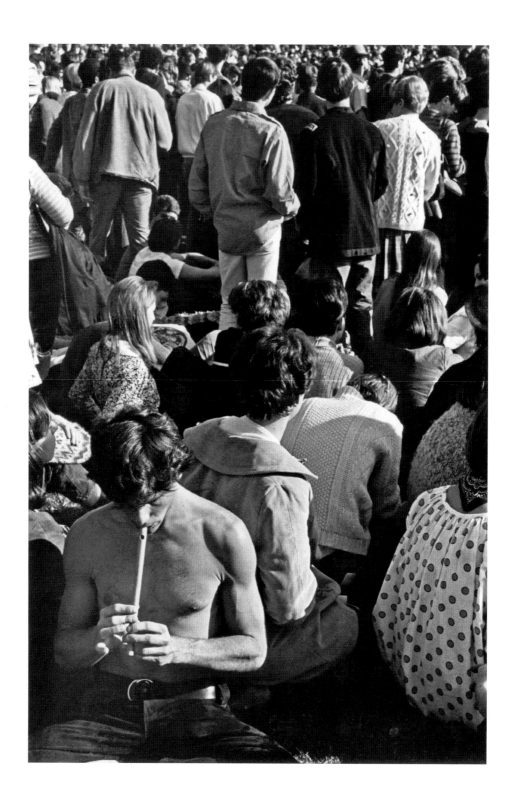

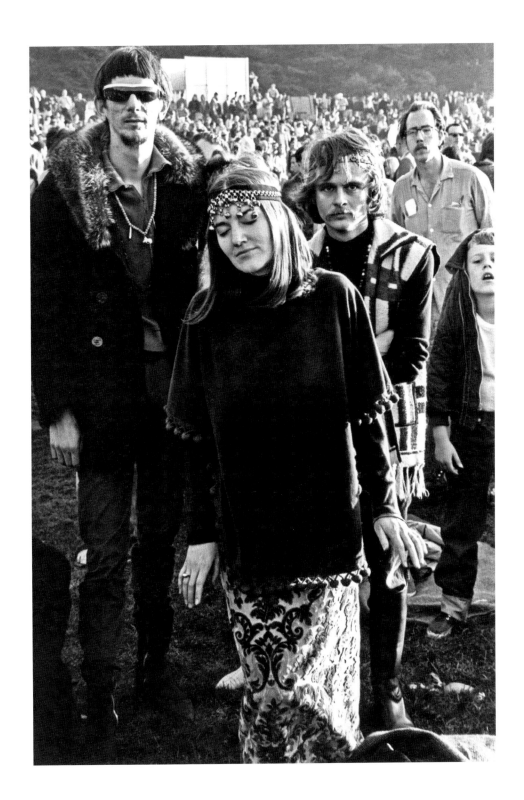

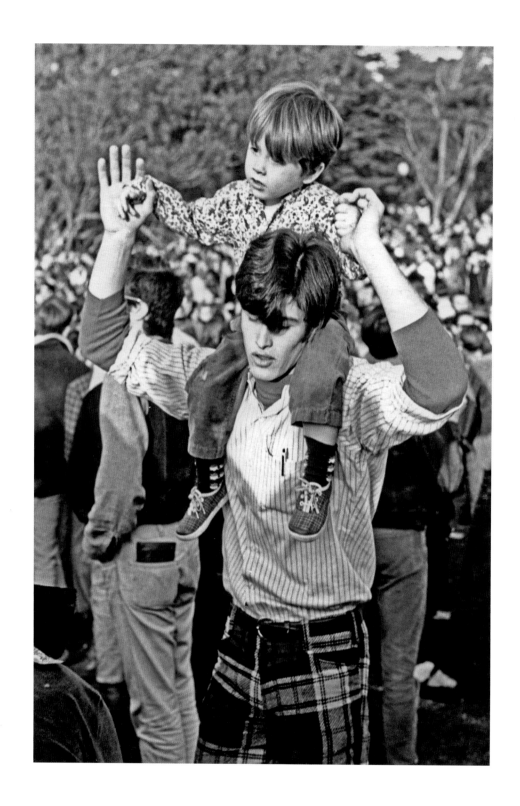

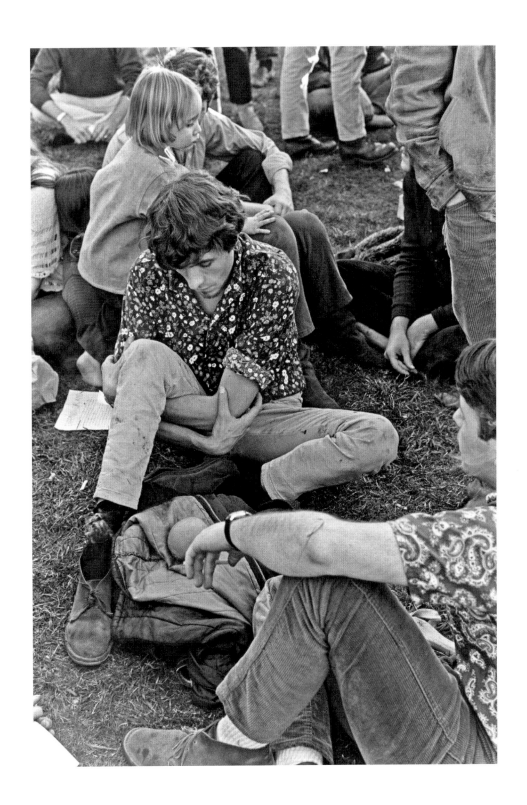

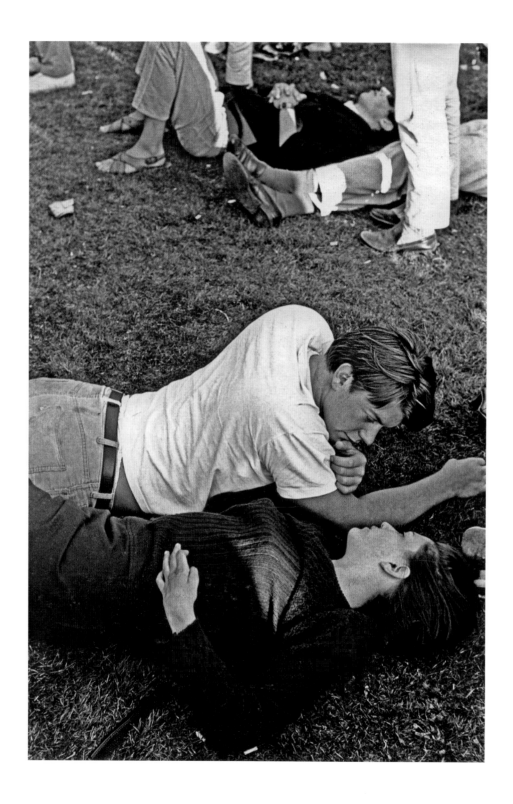

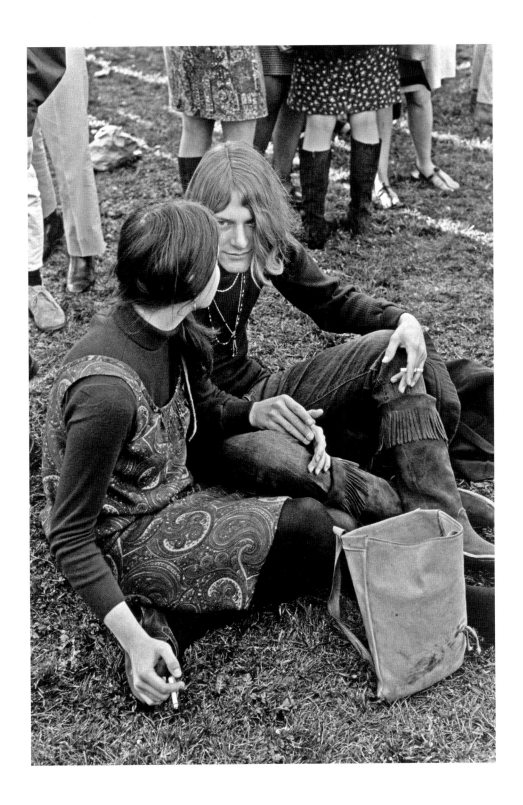

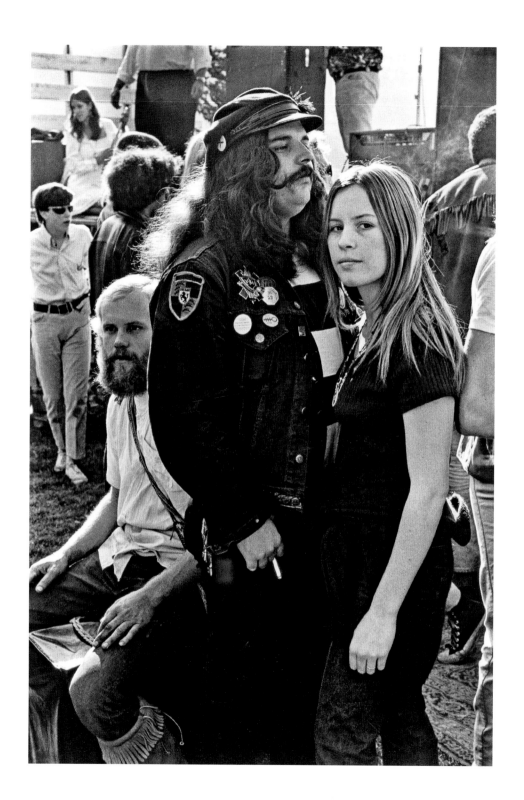

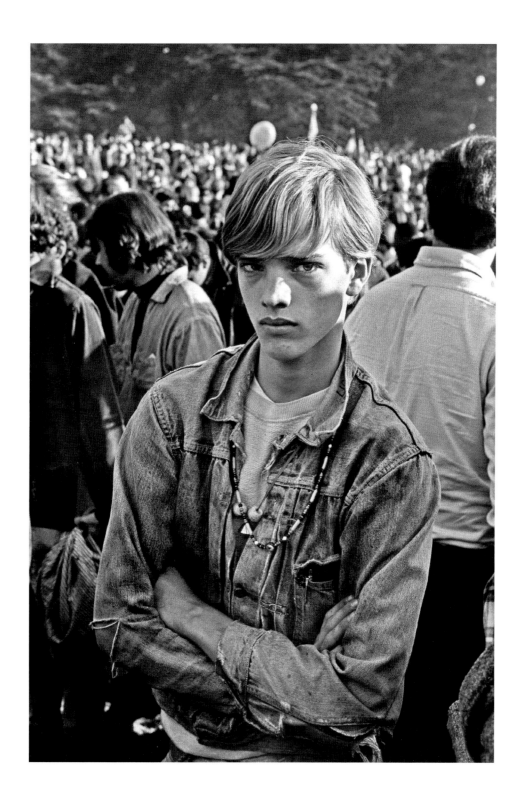

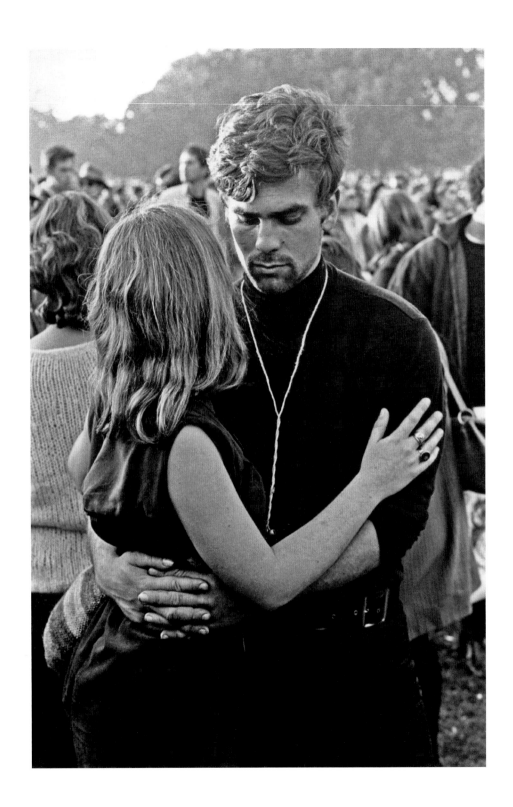

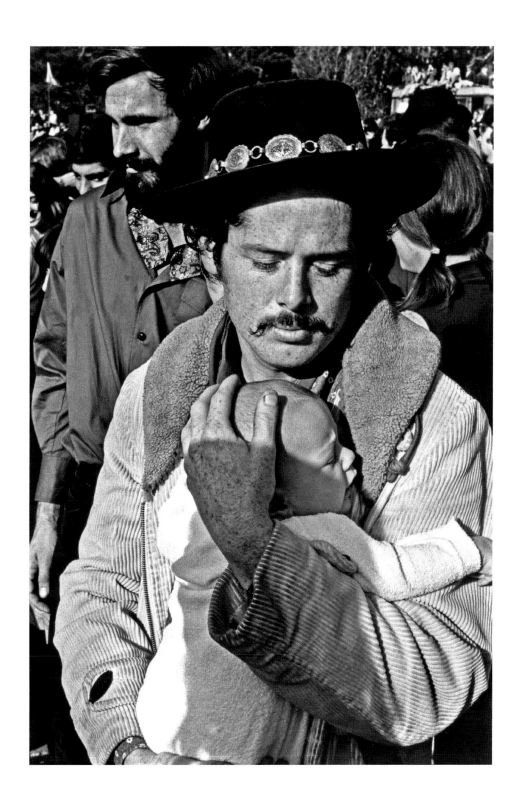

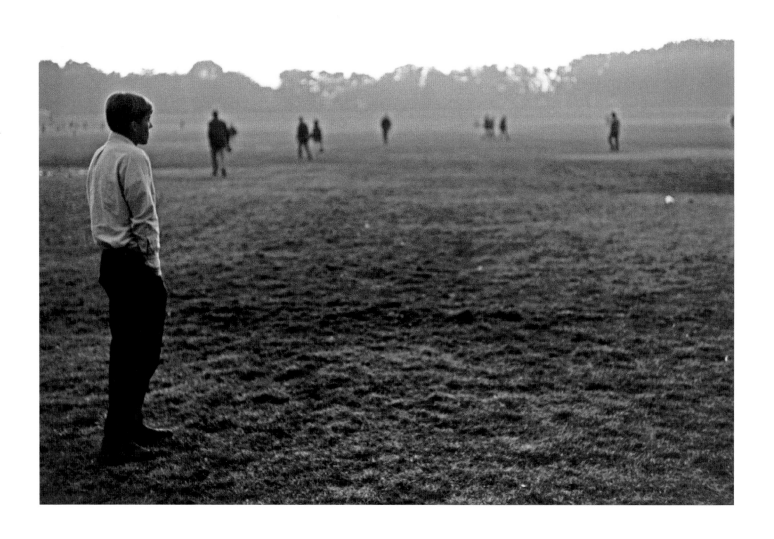

BILL GEDNEY
A Time of Youth

PHILIP GEFTER

With the clarifying distance of time, the work of William Gedney, a well-regarded but little-known photographer of the twentieth century, has garnered renewed significance in the realm of his canonized contemporaries—Robert Frank, Lee Friedlander, Diane Arbus, Bruce Davidson, and Danny Lyon. The documentary tradition in which Gedney worked is the backbone of the medium of photography itself, from William Henry Fox Talbot's *The Pencil of Nature*, in 1844, with the very first photographs of actual objects in the visible world—a leaf, a house, a monument, a shelf of books—to Alexander Gardner's history photographs of officers and soldiers, dead and alive, during the U.S. Civil War; Brassaï's voyeuristic glimpses of the nocturnal demimonde of Paris; Walker Evans's seminal 1938 book, *American Photographs*; and, of course, *The Americans*, by Robert Frank, which was conceived less as a document than as an artist's book.

During Gedney's lifetime, between 1932 and 1989—abbreviated by his early death at the age of fifty-six from exposure to the AIDS virus—he made a half dozen distinct bodies of work. His first, *The Farm* (1955–1959), draws on the tone of observation found in his most direct antecedent, Walker Evans. Gedney's subsequent series of pictures advance a visual dialogue that takes a set of cues from other photographers of his own generation. While I intend in this essay to elucidate Gedney's artistic impulse in making the series *A Time of Youth* and his preparations for the book, his earlier work is relevant to an edifying understanding of what initially led to the photographs he made in San Francisco that constitute *A Time of Youth*.

His first series, *The Farm*, is a visual meditation on his family homestead in Upstate New York. He had moved to New York City to study painting and design at the Pratt Institute, and he returned home for this photographic enterprise, bringing a literary regard to his subject. "Frame, proportion, perspective, the value of light and shade, all are determined by the distance of the observing eye," wrote Eudora Welty in *One Writer's Beginnings*, which Gedney would copy into his journal many years later.[1] His photographs of his grandparents on the farm are humble, straightforward in approach, and keen with clear-eyed observation, whether the image of his grandmother standing at the kitchen sink or of his grandfather stacking hay with a pitchfork.

Although the pictures of *The Farm* have a kinship with Walker Evans's photographs of tenant farmers in Hale County, Alabama, in 1928; with Wright Morris's pictures of farmhouses in the western landscape; and with Dorothea Lange's migrant farmworkers during the Dust Bowl, Gedney's distinct signature grows in evidence throughout this series. In these images, he depicts the simplicity of daily existence with metaphorical resonance. His concise visual logic is a kind of invisible architecture out of which a feeling surfaces—a glimmer, more often than not—of his own sense of isolation and longing. He made more than a few pictures of his grandmother, for example, showing her either at the screen door staring out with idle reserve (see fig. 1) or sitting in a rocking chair in the afternoon light, her hands in her lap, gazing out the window with a same-as-it-ever-was resignation—waiting for a phantom something that seemed to be missing.

In 1964 Gedney traveled to Eastern Kentucky and sought out a family in the mining region of Appalachia as his next subject of photographic contemplation. For almost two weeks, he lived with Willie and Vivian Cornett and their twelve children in poverty-stricken Big Rock, Kentucky, immersing himself in their lives as a boarder-with-a-camera, photographing their daily interactions and activities as if he had always been a member of their family. Willie refused to take the two dollars a day Gedney offered him, but he was touched by the twenty-two dollars the photographer left on the table with a thank-you note upon his departure.[2]

Gedney's pictures of the Cornett family are remarkable for their immediacy, intimacy, and surprising grace amid the bleak circumstances of poverty. The brothers, often shirtless, ranging in age from pre-adolescence to early adulthood, tinker with their broken-down cars, either huddling over an engine or standing around with cigarettes in their hands. In one picture, five bare-chested brothers stand in a tribal circle, conferring about

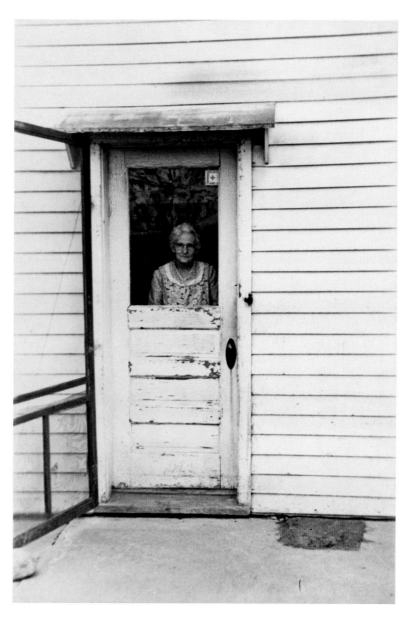

FIG. 1. *Farm*, ca. 1955–1959. William Gedney Photographs and Papers, Box 16, Folder 1, David M. Rubenstein Rare Book & Manuscript Library, Duke University.

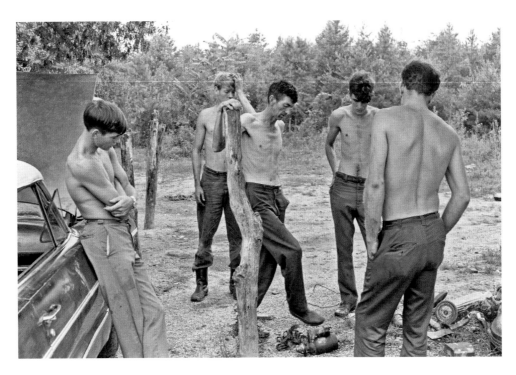

FIG. 2. *Kentucky, 1972.* William Gedney Photographs and Papers, Box 7, Folder 9, David M. Rubenstein Rare Book & Manuscript Library, Duke University.

something important. All of them are staring at the ground, some with folded arms, others with hands in their back pockets, each one in isolated deliberation, while Gedney captures their unintended choreographic gestures as a physical dialogue between one and another (fig. 2). "This photograph was about the relaxed and natural rhythms of those men's bodies—the drape of bare arms, necks, curved backs in repose, gestures that bespoke whole lives and their connections," writes the author and photographer Margaret Sartor. "The facts described a hard life and generations of it, but in this moment these men were also, undeniably, *beautiful*."[3]

Five years earlier Bruce Davidson made a photographic series about a Brooklyn street gang, young men roughly the same age as the older Cornett brothers, perhaps as impoverished, whose urban swagger added a menacing aspect to their aimlessness. Davidson, at the time barely older than his subjects, insinuated himself into their lives to gain their trust, just as Gedney had with the Cornetts. Yet aside from the respective intentions of

the two photographers, in Davidson's street gang pictures the sexual energy between the boys and their girlfriends is palpable, while in Gedney's pictures the sexuality, such as it is, derives from the longing of the photographer, both for the touch of his subjects' skin and, equally, for the fraternal closeness that suffuses their daily activities.

Gedney left traces of what might be called his credo in journal inserts throughout his life. In 1983 he recorded this passage by Lillian Ross from an essay on writers in a book of collected writings called *Takes*: "They tried to set down what was true, what could be seen and heard and touched, what could be tested and confirmed by others: what was true. They wrote about particulars; they didn't generalize. They didn't analyze; they tried to understand but not over interpret. They did not indulge in flourishes; they did not feel a need to show off."[4] It is an apt description of his own approach to making art with the camera—without pretense or obvious style, allowing his subject matter to be what it is. Yet because of his choices about what to shoot, where to stand, and when to release the shutter, the resulting pictures reflect his own intelligence and sensitivity as a keen observer.

The emotional austerity in Gedney's rendering of the farm of his own childhood strikes a telling counterpoint to the restless eroticism in the Kentucky work. "To love in this world is to be a fool, to open one's heart is to be hurt," Gedney wrote in his notebook in 1962, a conclusion necessarily underscored by the punitive homophobic attitudes of mid-twentieth-century America.[5] It becomes clear from his notebooks that Gedney frequented gay clubs and engaged in casual sexual encounters with men, yet he kept that part of his life strictly partitioned from everything else. In 1963, while supporting himself with a job as a graphic designer at Time-Life Books, Gedney met Lee Friedlander and his wife, Maria. "He plunged into our domesticity—walks in the woods near our house, meals with us and our two children, lots of talk of photographs, travel, music, films, books," Maria Friedlander recounted. "The visit over, Bill headed home to Brooklyn and to a life we didn't know very much about, the life of a loner, a very private man."[6] Over the years, as their friendship deepened, Maria would ask him with some delicacy if he ever thought of marriage, and his answer was always "a bellowing laugh . . . a signature laugh . . . part of the Gedney vocabulary," she said. "Whenever Bill answered the question with that laugh or used it as a comment upon some statement I made, I learned that I had come upon a gate that he kept firmly closed."[7]

In 1966, with recommendations from Walker Evans, who was then the picture editor at *Fortune* magazine, and John Szarkowski, director of the photography department at the

Museum of Modern Art, New York (MoMA), Gedney was awarded a Guggenheim Fellowship. As Robert Frank had photographed across America on a Guggenheim Fellowship in the mid-1950s, followed by Garry Winogrand, also on a Guggenheim, in 1964, Gedney set out on his own systematic road trip across the country, making photographs along the way. Toward the end of this odyssey, he arrived in San Francisco and felt compelled to stay there and photograph for more than three months.

Once again, just as he documented his own family in *The Farm* and then situated himself inside the Cornett family to make the Kentucky photographs (surprisingly, he never made a deliberated photographic chronicle of his surrogate family, the Friedlanders), while exploring the streets of San Francisco Gedney gravitated toward a group of itinerant hippies—a family by any other name. He entered their communal circles and photographed them in the course of their daily activities as they squatted in one vacant house and then another, slept together on mattresses on the floor, sat around smoking cigarettes or getting stoned, gathered on stoops and in neighborhood parks, strummed guitars, played the recorder on the streets, and attended music festivals.

Gedney's subjects, a generation younger than he, were exploring a new way of being—in opposition to the bourgeois conventions of his own youth. He could not know it at the time, but he was documenting the colonization of the "flower children" in what would become the very epicenter of the 1960s counterculture, an area of San Francisco at the intersection of Haight and Ashbury Streets to which disenfranchised youth had migrated from all over the country; the sexual revolution was born out of their unorthodox living arrangements, which were communal by necessity as much as in tribal solidarity, and was fueled by the heightened sensory stimulation of marijuana and psychedelic substances. The term *Summer of Love* was coined by the media to mark the new social phenomenon of "Be-Ins" and "Happenings" in Golden Gate Park in 1967, only months after Gedney had completed his series. This so-called youthquake was later given cultural definition as the "Age of Aquarius," after a song from the emblematic Broadway musical *Hair*, which opened in New York in 1968—the same year Tom Wolfe published his seminal book of essays *The Electric Kool-Aid Acid Test*, about that mind-expanding cultural moment.

In Gedney's pictures, the flower children do not appear lighthearted, nor do they reflect the creative optimism or "tripped-out bliss" that characterizes the mythology of the free love movement. Instead, they remain unequivocally disenfranchised. The emotional tenor throughout these pictures is one of forlorn, if soulful, disaffection. In the very first spread of his maquette, two facing pictures show individual young men who look enough

alike to be mistaken for the same person, each one in fetal repose, one on blankets drap-ing a couch, the other lying above the covers on a bed. In some of the pictures, reclining individuals or couples are consumed within a swirl of unkempt blankets and sheets—as if caught in crosscurrents that render them virtually inert (figs. 3 and 4).

In one haunting image, a young man is curled up asleep in an armchair as another figure, almost in silhouette, leans against the doorway, his back to the room, looking down into a stairwell (fig. 5). A mood of idle dislocation is established by the interplay of gestures, the reclining man's knees, side by side, facing one direction, in visual dialogue with the standing figure's arms, bent and parallel with his hands in his pockets, in perfect counterpoint.

On the surface, the pictures in *A Time of Youth* are less resolved than the photogra-pher's two previous bodies of work. Inherent in the look of these photographs—their com-positional asymmetry, less-articulated tonal ranges, and denser light—is the expression of Gedney's own existential uncertainties in the wake of his subjects' "floating existence," as he defined it, and his proximity to their unselfconscious sexual activity.[8] In one play-fully erotic image, a handsome young man with long, well-groomed blond hair and mut-tonchop sideburns, who does not appear to be part of the band of hippies, leans lan-guorously against a store window in a tight, boldly striped long-sleeve pullover; his finely checked pants are tight enough to outline his genitals in semi-arousal (fig. 6). At first glance, his hands appear to be crossed at his waist, posing an alluring visual riddle; in fact, they are the hands of the girl standing behind him, her arms slipped under his own, her face just visible above his right shoulder. On his face is what is called, in street parlance, a "shit-eating" grin.

"I must tell you that we artists cannot tread the path of Beauty without Eros keeping company with us and appointing himself as our guide," writes Thomas Mann in *Death in Venice*.[9] Gedney would later echo the presence of Eros as he wrote about the evenings in San Francisco, describing in his notebook a "restlessness, the need to search in forbidden places, but always coming back to the self, alone."[10]

While the couples in his pictures are mostly heterosexual, some photographs allow an ambiguous reading. Ultimately, for Gedney, the photographs in *A Time of Youth* register a new visual vocabulary, one that seems to communicate Gedney's own dislocation within the experience as much as the anxious uncertainties of the youth they depict.

While Gedney was photographing the hippie tribe in San Francisco, John Szarkowski at MoMA was putting together what would become a landmark exhibit in the history

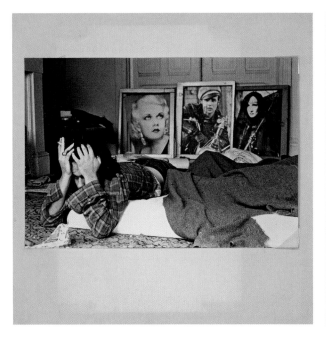

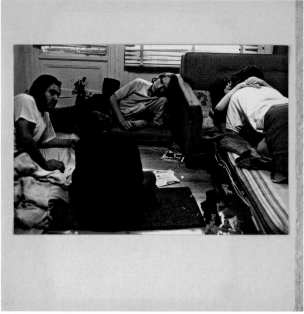

FIG. 3. Page 76 from Gedney's book design for *A Time of Youth*, 1969. William Gedney Photographs and Papers, Box 158, Folder 2, David M. Rubenstein Rare Book & Manuscript Library, Duke University.

FIG. 4. Page 42 from Gedney's book design for *A Time of Youth*, 1969. William Gedney Photographs and Papers, Box 158, Folder 2, David M. Rubenstein Rare Book & Manuscript Library, Duke University.

of photography, titled *New Documents*, which introduced the work of Diane Arbus, Lee Friedlander, and Garry Winogrand. Szarkowski asserted that until then, the aim of documentary photography had been to show what was wrong with the world as a way to generate interest in rectifying it. But this show signaled a change. "In the past decade a new generation of photographers has directed the documentary approach toward more personal ends," he wrote in the wall text for the show. "Their aim has been not to reform life, but to know it."[11]

Szarkowski had defined a mutational shift in photographic art making at the very moment that Gedney's own artistic impulses exemplified that shift. Gedney's work in San Francisco captured not only the chaos and confusion in the lives of his subjects but, equally, his existential turmoil in relation to them. Upon his return to New York, Szarkowski offered Gedney a one-man show at MoMA. The exhibition—which included images

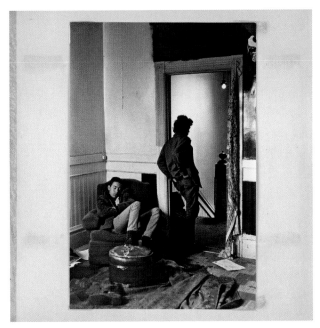

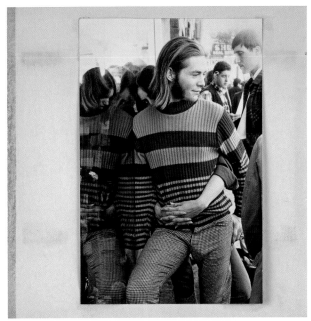

FIG. 5. Page 53 from Gedney's book design for *A Time of Youth*, 1969. William Gedney Photographs and Papers, Box 158, Folder 2, David M. Rubenstein Rare Book & Manuscript Library, Duke University.

FIG. 6. Page 25 from Gedney's book design for *A Time of Youth*, 1969. William Gedney Photographs and Papers, Box 158, Folder 2, David M. Rubenstein Rare Book & Manuscript Library, Duke University.

of the Cornett family in Kentucky and the youth in San Francisco—opened in December 1968.

"Gedney has not created polemical or propaganda pictures," states the MoMA press release for the exhibit. "Rather, with grace and clarity, he depicts the personal and universal aspects of two groups that society considers outside its value system: the San Francisco radicals who have dropped out by choice, and the mountain people who have been dropped out by the choice of history." In the wall text, Szarkowski observes that the individuals in Gedney's pictures are more complex and more interesting than the clichés: "These are not photographs of hillbillies and hippies, but of people living precariously under difficulty. . . . Gedney, being a good witness, does not attempt to direct our verdict concerning the quality of these lives. He does allow us to see that they are in many ways much like our own."[12]

Soon after his exhibit at MoMA, Gedney, who had begun a preliminary sequence of his San Francisco pictures, made an elaborate notebook entry about the structure of the book he intended for the work. "I am attempting a literary form in visual terms," he wrote.[13] He then mapped out a distinct narrative structure, not unlike that of a novel, with seven individual sections: "The morning, *awakening*"; "The day outside"; "Change and re-establishing"; "The day inside"; "The night"; "The new pad"; and "Codification."

He specified the proportion of the book—8½ × 8½ inches—allowing for a variation in size so long as the book remained in square format. His final dummy, to which this publication maintains exacting fidelity, adheres to his narrative structure, absent any identifying section headings or breaks. "I am telling a story with characters that reappear and scenes that are repeated," he wrote in his notebook entry.[14] Definitive, if unidentified, protagonists do appear throughout the pictures in the various activities that constitute its sequential narrative; leitmotifs, too, permeate the series, such as the recorder player who shows up from time to time throughout the work.

In Gedney's notes, he divulges something of a revelation about the San Francisco youth he had documented, yet his conclusion is colored by the distrust that made him keep his own feelings at a distinct protective remove. "The power of youth, the proclamation of a new way . . . is only the old way made to look new, the power of rebirth, the breaking down of the self if only for a few hours to become part of a crowd, a community, the feeling of spring and new trust in love, however false."[15]

Gedney included an epigraph by John Cage at the beginning of the dummy: "They seem to be doing happy things sadly, or maybe they're doing sad things happily." An artistic deity for Gedney, Cage strikes an oracular note about the book that, by all intents and purposes, reflects the tone of the story Gedney found himself telling with the pictures.

The title *A Time of Youth* first appears in his journal entry on March 19, 1969, and he completed the maquette on April 16 that year. Lisa McCarty, the curator of the Gedney archive at Duke University from 2014 to 2019, reported: "While I don't have a definitive quote or journal entry from Gedney on why he chose 'A Time of Youth' as the title, I can confirm that he considered these in journal entries at some point in the process: 'Youth'; 'A Cult of Youth'; 'A Voyage of Youth'; 'An Odyssey of Youth'; 'Youth Odyssey'; '91 Photographs—San Francisco 1966–1967'; 'Youth—91 Photographs—San Francisco 1966–1967.'"[16]

In the mid-1960s Duane Michals was the first to introduce the single-image, multi-frame narrative sequence to modern photography. Whether or not Gedney was influenced by Michals's sequences directly, the fact of their contemporaneous exploration of

storytelling in photographic imagery is noteworthy. Michals departed from factual documentation by constructing the circumstances in his pictures; his stories from beginning to end were invented, often with allegorical intent. Gedney's stories, by contrast, were discovered in the moment, observed and captured from real life, and they unfold in a nonlinear narrative with the accumulation of images in book form.

The trajectory of Gedney's work is consistent with the evolution of photographic art making in his own time, from the bedrock documentation of Walker Evans and Robert Frank to his direct contemporaries in their depictions of contemporary tribal forms, both Bruce Davidson, with *Brooklyn Gang*, and Danny Lyon, with his series *The Bikeriders* in 1968. As Gilles Mora writes, "Gedney seemingly always photographed the same way throughout his career, using the same stylistic tools drawn from documentary photography—a small format, a direct focus, black and white prints, and never tempted by anything beyond an unaffected vision of reality."[17] Mora continues:

> *A Time of Youth* is not merely a project on the hippie communes of that era but rather an homage to Youth, Gedney's great motivation. Many of his photos are a hymn to an age he knows to be transient, full of ambiguities, freighted with a fascinating immaturity. William Gedney's gaze possesses the emotionally moving lucidity of a man who understands he is already excluded from that fragile and dazzling beauty. His most endearing portraits reveal, behind an adolescent innocence, the seeds of a sexual attraction that never leaves him, one that he urgently needs to capture and that, he understands, has become the absolute driving force of his photographic impulse. Gedney himself described this impulse as no more than "The project of the mind into flesh."[18]

Gedney was urbane and well-read, a committed teacher at the Cooper Union and the Pratt Institute, and a single-minded artist. "I am concerned with making a good photograph—an uncropped blending of form, value and content," he wrote in a draft letter to a publisher about *A Time of Youth*. "I prefer the ordinary action, the intimate gesture, an image whose form is an instinctive reaction to the material."[19]

His inclination to make books of his photographs—there are maquettes for seven books among his papers at Duke University—may have been motivated by the absence of platforms for viewing photographs in the era in which he worked. Until the early 1960s there had been only one photography gallery in New York—the Limelight Gallery—which also doubled as a West Village coffee house. Helen Gee, who owned the gallery, barely sold

a picture and had to close it in 1961. There was nothing of a market for lens-based art and scarcely any demand for photography books. During the landmark *New Documents* show at MoMA in 1967, Diane Arbus, Lee Friedlander, and Garry Winogrand all received inquiries from a guard at MoMA about buying their pictures. "Diane and Garry and I talked about it because we didn't know what [to do]," Friedlander recalled fifty years later. "We'd never sold a print. We decided that twenty-five dollars was right. And that was the only sale we made."[20] Not until 1969 would Lee Witkin open his gallery, the only photography gallery in New York for several more years; his first exhibition introduced several emerging photographers: Duane Michals, George Tice, and Burk Uzzle. Their prints were priced at fifteen to thirty-five dollars. Only three were sold.

While it took enterprise and determination for Gedney to conceive of the San Francisco series as a book, necessity, too, was the mother of invention. There was simply no other platform for the work to be seen as an entity. That it is being published, finally, after fifty years, is a tribute to the scholarship and determination of Lisa McCarty and Margaret Sartor.

In 2000, on the occasion of an exhibition of Gedney's work at the San Francisco Museum of Modern Art, the photography critic Vince Aletti wrote that the photographer "put his passion, his longing, his care, and his intelligence into tough, tender pictures that burn even more brightly in their absence."[21] In *A Time of Youth* Gedney was focused on making good photographs, one at a time, as he followed his exotic young subjects around; yet, without quite realizing it, he succeeded in producing a chronicle of historical relevance while leaving traces of his own existential condition that resonate beyond his personal experience.

New York, 2019

NOTES

1. William Gedney, notebook entry, November 20, 1985, William Gedney Photographs and Papers, Box 179, Folder 2, David M. Rubenstein Rare Book & Manuscript Library, Duke University.
2. Margaret Sartor, "What Was True," in *What Was True: The Photographs and Notebooks of William Gedney*, ed. Margaret Sartor and Geoff Dyer (New York: W. W. Norton and Lyndhurst Books of the Center for Documentary Studies, 2000), 23.
3. Quoted in Sartor and Dyer, *What Was True*, 16.
4. Quoted in Sartor and Dyer, *What Was True*, 17.
5. William Gedney, notebook entry, 1962, William Gedney Photographs and Papers, Box 175, Folder 1.

6. Maria Friedlander, foreword to Sartor and Dyer, *What Was True*, 7.

7. Quoted in Sartor and Dyer, *What Was True*, 8.

8. Quoted in Sartor and Dyer, *What Was True*, 8.

9. Thomas Mann, *Death in Venice*, trans. David Luke (New York: Bantam Classics, 1988), 340.

10. Quoted in Margaret Sartor, "Short Distances and Definite Places," in Gilles Mora, Margaret Sartor, and Lisa McCarty, *William Gedney: Only the Lonely, 1955–1984* (Austin: University of Texas Press, 2017), 97.

11. Quoted in Sarah Hermanson Meister, "Newer Documents," in *Arbus, Friedlander, Winogrand: New Documents, 1967*, ed. Sarah Hermanson Meister (New York: Museum of Modern Art, 2017), 9, with the full John Szarkowski wall text as the frontispiece.

12. Museum of Modern Art, press release no. 130, for release December 17, 1968, with wall text and archive exhibition history, https://www.moma.org/documents/moma_press-release_326598 .pdf.

13. William Gedney, journal entry, March 22–23, 1969, William Gedney Photographs and Papers, Box 176, Folder 8.

14. William Gedney, journal entry, March 22–23, 1969, William Gedney Photographs and Papers, Box 176, Folder 8.

15. William Gedney, undated journal entry, William Gedney Photographs and Papers, Box 175, Folder 11.

16. Lisa McCarty, email to the author, November 1, 2019.

17. Gilles Mora, "William Gedney, So Similar, So Different, Alone Are the Lonely," in Mora, Sartor, and McCarty, *William Gedney: Only the Lonely*, 9.

18. Mora, "William Gedney, So Similar, So Different," 12.

19. Quoted in Vince Aletti, "William Gedney: A New View of the Photographer Who Looked at Life on the Margins," *Out* magazine, February 2000, 32.

20. "Lee Friedlander in Conversation with Giancarlo T. Roma," Live from the New York Public Library, June 20, 2017, https://www.nypl.org/events/programs/2017/06/20/passion-projects -lee-friedlander-giancarlo-t-roma.

21. Aletti, "William Gedney," 33.

WILLIAM GALE GEDNEY
467 Myrtle Avenue
Brooklyn 5, New York
UL 7-2276

a Time
~~A TIME~~ OF YOUTH

87 photographs ~~taken~~ San Francisco 1966-1967

"They seem to be doing happy things sadly,
or maybe they're doing sad things happliy."

John Cage

Note: The pictures in this dummy are
rough work prints not finished
prints.

AFTERWORD

LISA MCCARTY

"they seem to be doing happy things sadly."
John Cage on looking at my San Francisco book.
"or maybe they're doing sad things happily."
—William Gedney, journal entry, May 25, 1968

On May 25, 1968, William Gedney showed John Cage the second draft of his "San Francisco book," which would ultimately be completed as *A Time of Youth*. Cage may have been the first to see the work in progress, and it is clear that his reaction made an impression on Gedney. Eleven months later, Gedney emblazoned Cage's quote on the front cover of his fifth and final design for the book (see the accompanying image). The Cage quote and an Eric Hoffer quote that follows on the subsequent page are the only texts included in this final design. Gedney filled three journals with reflections on his experiences in San Francisco and collected numerous quotes for possible inclusion in the book. But in the end, he chose just four sentences to prime readers for the subsequent images. This level of subtlety and precision is characteristic of Gedney but belies the complexity of this ambitious project.

At 104 pages, *A Time of Youth* is Gedney's lengthiest complete book design. His con-

(*opposite*) Cover and note for *A Time of Youth* by William Gedney, 1969. William Gedney Photographs and Papers, Box 158, Folder 2, David M. Rubenstein Rare Book & Manuscript Library, Duke University.

cept for the work is also more rigorous and far-reaching in scope than the six other books he finished in his lifetime. In his typewritten statement about the work (see the image in the introduction), Gedney refers to *A Time of Youth* as an "attempt at visual literature, modeled after the novel form (characters progress throughout the book and other literary devices are used in the format)."[1] In a journal entry dated March 22–23, 1969, Gedney also describes the elaborate seven-section structure he conceived to sequence the photographs (see chronology fig. C.12):

It is divided into 7 sections

1. the morning awaking—
 Establish the need for love and
 its rejection or inability to
 [accept] it. Each person
 retreating back into his own
 ego. The separateness of
 bodies asleep. The birth

2. the day outside
 formed for the most part of
 groups of one or two
 life in the streets and park
 the solitary singer and the
 lovers—the wanderers
 the need to share, the brief
 warmth of two—

3. change and reestablishment—
 the impermanence of floating
 existence—the new place to
 stay but the feeling that it
 is not permanent, at best
 safe for a few days
 a life can not be based on
 physical attraction alone
 love is not enough.

4. the day inside
 the dreams of the idle
 the boredom of nothingness
 brings separation.
 The lovers part, the separation
 is complete, inevitable

5. The night
 restlessness the need to search
 in forbidden places but always
 coming back to the self
 alone. The futility of escape

6. The new pad
 The lover separated dominated
 by popular images (unable to
 escape from the middle class)
 The inter play of the sexes—
 boredom. emptiness

7. the codification
 The powers of youth, the proclamation
 of a new way but it is only
 the old way made to look new
 The power of rebirth, the breaking
 down of the self if only for a few hours
 to become part of a crowd, a community
 A feeling of spring and new trust in
 love how ever false.[2]

This sophisticated structure, which also progresses from morning to night, is at once lyric and searing. In the 1960s few artists were approaching the photobook medium in such a manner. And while many photographers conceive of such intricate sequences today, very few choose to make their intentions explicit; fewer still document their own process to the extent that Gedney did. That we have such detailed, clear-eyed information about Gedney's process and in his own hand is a testament to his dedication as an archivist of

his own work. That said, Gedney spends just as many journal pages explaining his intentions as he does criticizing his own work. Gedney's March 22–23 entry goes on to describe his dissatisfaction with some of his sections: "the book is weak in the nightmare area, section number 5, the drug scene, the sexual escape, the freakout scene, the despair. It is under stressed but I don't have the pictures to do it properly . . . so much of the drug thing is interior with very little exterior effects anyway. It is a mind thing and hard to show visually."[3] This journal entry was made about a month before Gedney ultimately completed the book design. It is one of many reflections that demonstrate Gedney's self-doubt and self-imposed perfectionism.

The March 22–23 journal entry also shows Gedney's self-awareness. In this passage he astutely observes one of the challenges inherent to the making and interpretation of *A Time of Youth*. While much is transpiring in his subjects' inner lives, on first glance the young men and women depicted could be perceived as dispassionate or indolent. However, a closer reading of the images combined with Gedney's journal entries can reveal the vast interior distances traveled by his subjects. In addition to attempting a literary form, *A Time of Youth* also endeavors to document intangible states of mind: moments of anxiety and transcendence, the construction and dissolution of belief systems, the craving to be seen and to go unnoticed, the desire for acceptance and the woes of rejection, willful indecision and restlessness, joyful solitude and desperate loneliness; vulnerability. These are the states of mind that make up much of our lives and make us human, yet can only be pointed to in pictures. Gedney is clearly aware of this disparity and persists with his project anyway. Yet he also becomes increasingly aware of the contradictions within his temporary community.

In the process of living in San Francisco and making *A Time of Youth*, Gedney witnesses transformation and stagnation, both in his subjects and in himself. Gedney's own interior travels in San Francisco are chronicled in his copious journals and notebooks. While Gedney never overtly states why he went to San Francisco, it is clear that he initially approaches the city with idealism and reverence: "I remember coming across the bay bridge and seeing San Francisco for the first time. A white city, on moving levels, gleaming, it looked like a magic city in the distance" (see chronology fig. C.1).[4]

Gedney anticipated a gleaming city, and perhaps he also anticipated the ability to live freely there. In New York, Gedney outwardly siloed his personal and professional lives for fear of "punitive homophobic attitudes," as Philip Gefter notes in his essay in this book. But despite Gedney's high hopes for San Francisco, in an undated journal entry from 1967

he ultimately laments the sense of detachment and the traditional gender roles he encounters in San Francisco:

> Sexual relations are casual, attachments
> fleeting, love?
> yet the scene is mostly straight boy-girl
> sex, the women fit more in the
> traditional mode of femininity, the men
> more masculine
> couples with babies—children wanted
> the isolation of people under drugs
> the self interest[5]

While Gedney enters San Francisco with optimism, he leaves disillusioned. Gedney's experience then mirrors that of many who made the pilgrimage to Haight-Ashbury during the Summer of Love. In this sense *A Time of Youth* can also be read as a reflection of Gedney's own fervent and frustrated search for fulfillment. Again, to quote Gefter, *A Time of Youth* is an "expression of Gedney's own existential uncertainties" and "seems to communicate Gedney's own dislocation."

However, this period of dislocation and introspection in Gedney's life was paralleled by an intense period of work in the studio. The period from 1965 to 1969, in which Gedney lived in and made work about San Francisco, turned out to be the most prolific period in his career. Gedney's meticulous archive reveals that he accomplished the following during those years:

- 797 rolls of film exposed and developed
 (38 percent of overall career output)
- 549 11 × 14-inch exhibition quality prints produced
 (37 percent of overall career output)
- 6 handmade books including *A Time of Youth*
 (85 percent of overall career output)

These numbers were of course bolstered by the yearlong Guggenheim Fellowship period; however, the fellowship accounts for just one of the four years in this time span. This level of productivity was not sustainable, but it resulted in the bulk of Gedney's book projects and his only solo exhibition during his lifetime, at the Museum of Modern Art,

New York (MoMA), from December 1968 to March 1969. On April 16, 1969, Gedney completed his design for *A Time of Youth*, and his overall output decreased once this work was resolved.

In many ways, Gedney's San Francisco work is seminal, both personally and professionally. I believe this series was central to his development as an artist and led to his overall focus on bookmaking for the rest of his career. Among Gedney's unfinished book projects, there were plans for a book devoted to the images he made in Eastern Kentucky. In a journal entry from 1973, Gedney describes making a final selection of eighty pictures across 168 pages.[6] The scope and size of the Kentucky book are quite similar to those of *A Time of Youth*. These two series go hand in hand, as John Szarkowski recognized. When organizing Gedney's solo show at MoMA, he exclusively featured prints from these two series. However, while examples from the Eastern Kentucky photographs have been exhibited extensively since Gedney's death, the San Francisco photographs have languished by comparison. *A Time of Youth* is certainly radical in terms of Gedney's formal and conceptual approach when compared with the Eastern Kentucky photographs. However, these two bodies of work are equal in emotional intensity and in their powerful ability to communicate Gedney's own desires. Both series also demonstrate Gedney's long-term exploration of precariousness. *A Time of Youth* and *Eastern Kentucky Photographs* are two sides of the same coin.

In reflecting on the past five years, during which I have had the privilege to be immersed in this work, and on the preceding fifty years during which *A Time of Youth* lay dormant, I can't help but return to this idea of precarity that pervaded Gedney's life and work. Such precarity could easily have been reflected in the life of William Gedney's archive as well. The original design for this book might have been destroyed after Gedney's death if it weren't for the dedication of his chosen executors. Alternatively, this work might have remained unsorted and unseen if the Rubenstein Library had not dedicated resources to cataloging and digitizing it. But providing access does not always ensure use. If it weren't for the many dedicated artists, curators, educators, librarians, and scholars who decided to write about, exhibit, publish, and promote Gedney's work, his legacy would have remained precarious. To paraphrase one of Gedney's favorite poets, Walt Whitman, this book is just one verse in a much longer song. It has been an honor to contribute this verse to William Gedney's legacy; however, "the powerful play goes on."[7] There is much more within Mr. Gedney's archive that "craves the light."[8]

NOTES

1. William Gedney, statement accompanying the final design for *A Time of Youth*, 1969, William Gedney Photographs and Papers, Box 161, Folder 7, David M. Rubenstein Rare Book & Manuscript Library, Duke University.

2. William Gedney, journal entry, March 22–23, 1969, William Gedney Photographs and Papers, Box 176, Folder 8.

3. William Gedney, journal entry, March 22–23, 1969, William Gedney Photographs and Papers, Box 176, Folder 8.

4. William Gedney, undated journal entry, William Gedney Photographs and Papers, Box 175, Folder 2.

5. William Gedney, undated journal entry, William Gedney Photographs and Papers, Box 175, Folder 11.

6. William Gedney, journal entry, 1973, William Gedney Photographs and Papers, Box 160, Folder 4.

7. Walt Whitman, "O Me! O Life!," in *Walt Whitman: The Complete Poems*, edited by Francis Murphy (London: Penguin Books, 1996), 299.

8. Whitman, "O Me! O Life!," 298.

I remember coming across the bay bridge and seeing San Francisco ~~for the first time~~. ~~in the distance white a gleaming white~~ ~~spread~~ S A white city. ~~many~~ ~~raised~~ levels gleaming. it looked like a magic city in the distance. But then we tend to project emotions on distant objects. endow them with feeling that up close.

A many leveled city gleaming white in the distance. ~~suspended~~ like a back drop seen through the girders of the Bay bridge ~~trying~~ to drive and glance ~~the~~ ~~driving in~~ night lane the suspense and excitement of entering San Francisco for the first time.

Trying to pay attention to my driving ~~and to~~ and watching the approaching city suspended like a back drop ~~it~~ behind ~~through~~ the girders of the bay bridge a many leveled city gleaming white in the distance. ~~A magic city~~?

CHRONOLOGY OF WILLIAM GEDNEY'S WORK IN SAN FRANCISCO

LISA MCCARTY

DATE UNKNOWN, LIKELY AUGUST 1965

Gedney describes seeing San Francisco for the first time (fig. C.1).

TRANSCRIPTION OF FIG. C.1:

I remember coming across the bay bridge and seeing San Francisco for the first time. A white city, on moving levels, gleaming, it looked like a magic city in the distance[.] But then we tend to project emotions on distant objects[,] endow them with feeling that up close [. . .]

A many lev[el]ed[?] city gleaming white in the distance[,] suspended like a back drop seen through the girders of the Bay bridge[.] [T]he suspense and excitement of entering San Francisco for the first time.

Trying to pay attention to my driving and watch the approaching city suspended like a back drop behind the girders of the bay bridge[.] [A] many lev[el]ed[?] city, gleaming whit[e] in the distance.

(*opposite*) FIG. C.1. Undated journal entry. William Gedney Photographs and Papers, Box 175, Folder 2, David M. Rubenstein Rare Book & Manuscript Library, Duke University.

Gedney spends sixteen days in San Francisco, likely while working on *PORTRAITS 50 Contemporary American Composers*. During this time he makes approximately five hundred images across fifteen rolls of 35mm film.

SUMMER 1965

Gedney drafts and submits an application for a Guggenheim Fellowship (figs. C.2–C.4). He describes his project in the application as "Photographic Studies of American Life." His references include Walker Evans, John Szarkowski, Ben Schultz, and Walter Civardi.

MARCH 16, 1966

Gedney receives notification that he has been awarded a Guggenheim Fellowship.

MARCH 19, 1966

Gedney sends a thank-you letter to the Guggenheim Foundation secretary James Mathias (fig. C.5).

(*opposite and following pages*) FIGS. C.2–C.4. Guggenheim Fellowship application, 1965. William Gedney Photographs and Papers, Box 166, Folder 14, David M. Rubenstein Rare Book & Manuscript Library, Duke University.

William Gale Gedney

(A statement briefly outlining what the applicant wishes to do during
 the period for which the Fellowship is requested.)

I would like to be able to travel as widely as possible through out
the United States photographing aspects of our culture which I
believe significant and which I hope will become, in time, part
of the visual record of American history.

I have pursued this as far as I can with personal means,
being constantly interrupted by the necessities of earning a living,
to support the expenses of photography.

A grant will allow me to do what I can not do as a journal-
ist: cover in depth areas of American life that are largely ignored
or that the mass media are reluctant to cover.

It will give me freedom to devote all my time, thought, and
effort to photographing America as I see it.

(A statement briefly outlining what she applicant wishes to do
during the period for which the Fellowship is requested.)

William Gale Gedney

(An account of the applicant's career as a creative artist.)

 As a child, I liked to draw, but it was not a passing
phase and I continued to show progress through public school,
excelling in art classes, exhibits etc. By high school graduation
I was determined to be a painter. And on enrollment in Pratt
Institute I started to paint in earnest and explore various forms
of the visual arts.

 In my last year in art school (1954) one of the required
courses was a class in photography. From the first moment I held
a camera in my hands and started to use it, from my first roll of
film, I knew that I possessed a natural feeling for photography,
though I had never given the subject a serious thought before this
time. Following art school I continued to paint but photography
increasingly occupied my mind. I photographed more and painted
less. At some point I don't know exactly when, I knew I would
devote my life to photography.

 I have made my living as a graphic artist and photographer.
As a designer I came to specialize in the layout of photo-
journalism. As a commercial photographer I have had a variety of
assignments, from studio work in advertising to journalism.
In 1960 ~~I was the photographer of~~ ~~I photographed a~~ feature-length, sound motion picture.
I have always pursued my personal photography separate from
commercial/requirements.

 I am a still photographer, perferring an uncropped and
unretouched image. I do my own darkroom work and take great care
with finished prints. ~~My individual pictures always aim to becoming~~
are taken, to fit within a

part of a larger unitified theme, illustrating some level of American
life. But Most of my work is done in concentrated series (photo-
graphic essays). Many of these take months of shooting time and
result in hundreds of finished prints. I have laid out several
of these essays in book form, for possible publication. Below are
listed a few of the series I have done:

* A study taken at St. Joseph's School for the Death in the Bronx,
over a period of years, where I explored the processes of learning
and development of children with basic communication problems.
* A series taken in rural New York State on a small farm: the
last years of an old couple and the death of a way of life.
* An essay on the Brooklyn Bridge at night.
* A series taken in eastern Kentucky, on the people of the depress-
ed coal mining areas. (This is now under consideration by a major
publisher for a book.)
* Two series taken in California: one on Mexican-Americans and
of farm labor organization, the other on the life of young drifters
who are attracted to the west coast.

This list of some of the subjects I have covered does not
always reveal my exact purpose, for my work expresses itself comp-
letely in visual terms, never trying to duplicate what word can do.

My photographs are the product of a continuing dialogue
between myself and reality. I focus primarily on the human being
in conflict with, and in relation to, his environment. It is my
purpose to make permanent, with form and meaning, a visual record
of certain aspects of American life and culture.

March 18,1966

467 Myrtle Ave.
Brooklyn 5
New York

Mr. James F. Mathias
John Simon Guggenheim Memorial Foundation
90 Park Avenue
New York

Dear Mr. Mathias,

This is in acknowledgment of your letter of March 16,1966.

Words are inadequate to thank you for the Fellowship
granted me.

The Guggenheim Foundation has made possible the period
of uninterrupted work and travel I have longed for.
The chance to photograph extendedly some of the varied
and contrasting aspects of American life.

Thankyou for your belief in me and my work.

 Sincerely,

Gedney receives a grant of $6,500 from the Guggenheim Foundation and travels the U.S. by car for the majority of the fellowship period, June 1966–May 1967. He stops in most locations for just a few days at a time.

Gedney spends approximately ninety-nine days in San Francisco, interrupted only by brief trips to San Diego and Los Angeles. During this time he makes approximately 2,100 images across sixty-two rolls of 35mm film.

Gedney visits philosopher Eric Hoffer (fig. C.6) five times during his stay in San Francisco. Gedney transcribes into his journals passages from two of Hoffer's books: *The True*

(*opposite*) FIG. C.5. Letter from William Gedney to Guggenheim Foundation secretary James Mathias, 1966. William Gedney Photographs and Papers, Box 166, Folder 14, David M. Rubenstein Rare Book & Manuscript Library, Duke University.

FIG. C.6. Eric Hoffer, San Francisco, 1967. William Gedney Photographs and Papers, Box 9, Folder 1, David M. Rubenstein Rare Book & Manuscript Library, Duke University.

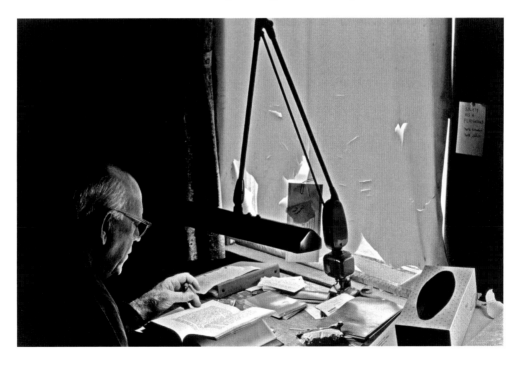

Believer: Thoughts on the Nature of Mass Movements (1951) and *The Passionate State of Mind, and Other Aphorisms* (1955). Gedney ultimately uses a quote from *The Passionate State of Mind* in the final design for *A Time of Youth*. He continues to correspond with Hoffer and his companion Lili Osborne after departing California. In addition to Hoffer, several other well-known writers and musicians appear in Gedney's images of San Francisco, namely, Allen Ginsberg, Tom Wolfe, and Ron McKernan of the Grateful Dead.

NOVEMBER 14, 1966

"The Pad" is first mentioned in Gedney's journals. A communal house where Gedney photographed and likely lived for some portion of his time in San Francisco, the Pad was just over a quarter of a mile away from the Grateful Dead's communal house on Ashbury Street.

JANUARY 14, 1967

Gedney attends and photographs the "Human Be-In" in Golden Gate Park. More than twenty thousand people are in attendance.[1] Many of the photographs in the final section of *A Time of Youth* were taken during the Be-In (fig. C.7).

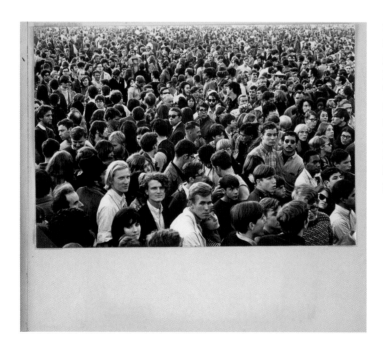

FIG. C.7. Page 85 from Gedney's book design for *A Time of Youth*, 1969. Photograph made at the "Human Be-In" in Golden Gate Park. William Gedney Photographs and Papers, Box 158, Folder 2, David M. Rubenstein Rare Book & Manuscript Library, Duke University.

Gedney leaves San Francisco and returns to New York by February 23.

FEBRUARY 1967–FEBRUARY 1968

Gedney completes photography for the books *PORTRAITS 50 Contemporary American Composers* and *Homage to Downtown Brooklyn*. He begins editing and designing books for both of these series, as well as *A Time of Youth*, simultaneously.

FEBRUARY 11, 1968

Gedney writes a journal entry noting a first draft of a book that includes images from San Francisco. This first design includes twenty prints from San Francisco and twenty prints from the Eastern Kentucky series.

MAY 25, 1968

Gedney develops a subsequent book draft with only images from San Francisco and shows it to John Cage. The journal entry (fig. C.8) from this day states: "'they seem to be doing happy things sadly.' John Cage on looking at my San Francisco book. 'or maybe they're doing sad things happily.'" This quote would later be used in Gedney's final design for *A Time of Youth*.

NOVEMBER 1968

Gedney loans thirty-two photographs to the Museum of Modern Art, New York (MoMA), for a solo exhibition curated by John Szarkowski. The exhibit includes twenty-two images from Kentucky and twenty-one images from San Francisco (fig. C.9).

DECEMBER 17, 1968–MARCH 10, 1969

Eastern Kentucky and San Francisco: Photographs by William Gedney is exhibited at MoMA.

JANUARY 16, 1969

Gedney's MoMA exhibition is reviewed by A. D. Coleman in the *Village Voice*.

MARCH 14, 1969

Gedney writes a journal entry noting that he has left a draft of the San Francisco book with an editor from Rover Publications. The entry states: "Leave San Francisco dummy with Stanley Appelbaum, Rover Publications, Chief Editor Strawbridge."

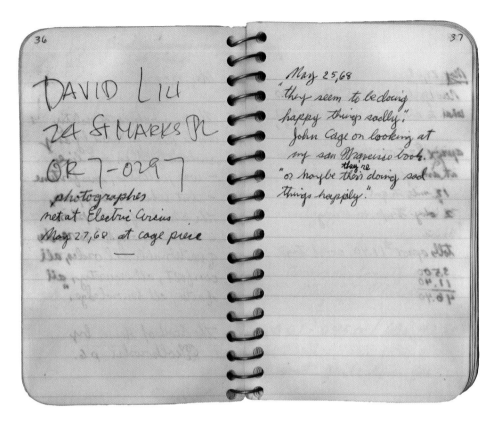

FIG. C.8. Journal entry, May 25, 1968. William Gedney Photographs and Papers, Box 175, Folder 5, David M. Rubenstein Rare Book & Manuscript Library, Duke University.

(*opposite*) FIG. C.9. Loan receipt issued to William Gedney from the Museum of Modern Art, 1968. William Gedney Photographs and Papers, Box 167, Folder 10, David M. Rubenstein Rare Book & Manuscript Library, Duke University.

The Museum of Modern Art

11 West 53 Street, New York, N.Y. 10019 Tel. 245-3200 Cable: Modernart

Date received.. November 1968

LOAN RECEIPT

The object(s) described below has (have) been received by The Museum of Modern Art as loan(s) under the conditions noted on the back of this receipt.

From William Gedney
 467 Myrtle Avenue
 Brooklyn, New York

for Exhibition: EASTERN KENTUCKY AND SAN FRANCISCO: PHOTOGRAPHS BY WILLIAM GEDNEY
 (December 17, 1968 - March 10, 1969)

Registrar Dorothy H. Dudley

Museum Number	Description	Insurance Value
68.1663	GEDNEY: (7699-37) (2 boys in crash pad)	$ 75.
68.1664	GEDNEY: 4744-14 (couple)	75.
68.1665	GEDNEY: 4683-36 (2 boys in room, 1 reading)	75.
68.1666	GEDNEY: 4811-4 (father and son)	75.
68.1667	GEDNEY: 1855-15 (harmonica player)	75.
68.1668	GEDNEY: 4688-26 (staircase of boys)	75.
68.1670	GEDNEY: 4593-23 (Prisoner of War)	75.
68.1671	GEDNEY: 4768-30 (desk sleeper)	75.
68.1672	GEDNEY: 1703-20 (bug and hand)	75.
68.1673	GEDNEY: 4765-13 (Harlow and sign hanger)	75.
68.1674	GEDNEY: 5207-28 (cat and sleeper)	75.
68.1675	GEDNEY: 1601-27 (2 awake, 1 in sleeping bag)	75.
68.1676	GEDNEY: 4719-33 (3 resting)	75.
68.1678	GEDNEY: 4520-26 (couple, girl awake)	75.
68.1679	GEDNEY: 4708-8 (2 fellows)	75.
68.1681	GEDNEY: 4673-22 (thinking)	75.
68.1682	GEDNEY: 4393-18 (5 on the beach)	75.
68.1683	GEDNEY: 4584-3 (moving)	75.
68.1684	GEDNEY: 4844-32 (sitting)	75.
68.1685	GEDNEY: 4843-27 (couple and purse)	75.
68.1686	GEDNEY: 4791-7 (girl and tub)	75.
68.1687	GEDNEY: 1128-31 (6 pairs of jeans)	75.
68.1689	GEDNEY: 1109-23 (porch chat)	75.
68.1690	GEDNEY: 1229-7 (cutting string beans)	75.
68.1691	GEDNEY: 1219-44 (cleaning gun)	75.
68.1692	GEDNEY: 1183-43 (the platform)	75.
68.1693	GEDNEY: 1172-11 (on the porch)	75.
68.1694	GEDNEY: 1113-7 (abandoned car)	75.
68.1695	GEDNEY: 1161-27 (3 in the car)	75.
68.1696	GEDNEY: 1139-26 (over the car)	75.
68.1698	GEDNEY: 1207-3 (girl)	75.
68.1699	GEDNEY: 1200-28 (boy)	75.

First appearance of the phrase "A Time of Youth" in Gedney's notebooks. While there is no record as to why Gedney selected "A Time of Youth" as the final title of the book, there is a record of his brainstorming process in his journals and book cover designs (figs. C.10 and C.11). The following phrases and fragments were likely considered as titles at some point in the two-year production process for the book:

Youth
A Cult of Youth
A Voyage of Youth
An Odyssey of Youth
Youth Odyssey
91 Photographs—San Francisco 1966–1967
Youth—91 Photographs—San Francisco 1966–1967
To make a voyage
The continual odyssey of Youth

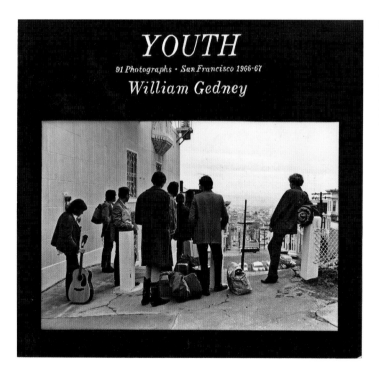

FIG. C.10. Undated book cover design. William Gedney Photographs and Papers, Box 161, Folder 7, David M. Rubenstein Rare Book & Manuscript Library, Duke University.

FIG. C.11. Journal entry with possible book titles, 1969. William Gedney Photographs and Papers, Box 175, Folder 5, David M. Rubenstein Rare Book & Manuscript Library, Duke University.

Gedney's journal entries from these dates describe a significant revision to *A Time of Youth* and Gedney's seven-part structure to organize and sequence the images (fig. c.12). There are also separate undated notebook entries describing the seven sections and correlating images, as well as quotes, to specific sections (figs. c.13 and c.14).

There is also an undated journal entry with a list of seven Bob Dylan songs. Gedney transcribed lyrics to at least four Bob Dylan songs in his San Francisco journals. It is possible Gedney conceived of a sequence of Dylan songs that would correlate to the seven sections of *A Time of Youth* (fig. c.15).

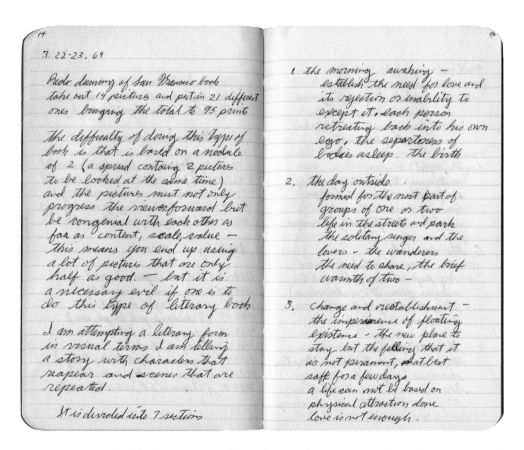

FIG. c.12. Journal entry, March 22–23, 1969. William Gedney Photographs and Papers, Box 176, Folder 8, David M. Rubenstein Rare Book & Manuscript Library, Duke University.

FIG. C.13. Undated notes on the seven-part image sequence for *A Time of Youth*. William Gedney Photographs and Papers, Box 176, Folder 2, David M. Rubenstein Rare Book & Manuscript Library, Duke University.

FIG. C.14. Undated journal entry with potential quotes for use in *A Time of Youth*. William Gedney Photographs and Papers, Box 175, Folder 12, David M. Rubenstein Rare Book & Manuscript Library, Duke University.

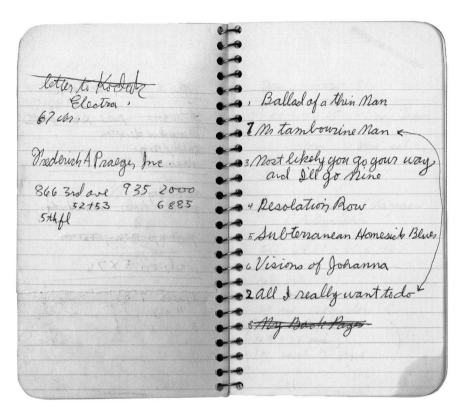

FIG. C.15. Undated journal entry with Bob Dylan song titles that may correlate to the seven sections of *A Time of Youth*. William Gedney Photographs and Papers, Box 176, Folder 1, David M. Rubenstein Rare Book & Manuscript Library, Duke University.

Gedney writes a formal statement about *A Time of Youth* (see the image in the introduction). His journal entries do not mention any further revisions to the book after this date. In the statement he describes his preferred sizing and format for the book. The final design includes 87 images, just over 3 percent of the 2,600 images he made in San Francisco. There is record of at least four preceding drafts with different image counts in Gedney's journals and notebooks. In addition to completing the book design for *A Time of Youth*, between 1967 and 1969 Gedney completed book designs for the following projects:

Italian Festival
Homage to Downtown Brooklyn
PORTRAITS 50 Contemporary American Composers
Brooklyn Bridge
Thirty-One Photographs

DECEMBER 27, 1975–JANUARY 4, 1976

Gedney returns to San Francisco for nine days. He makes approximately 1,500 images across forty-four rolls of film. In a later undated notebook entry, Gedney shows interest in using some of these images in a series focusing on "Gay Demonstrations" (fig. C.16). Very few of these images were printed before Gedney's death in 1989, but there are several examples in Gedney's finished prints (fig. C.17). Gedney also makes one of his few self-portraits in San Francisco on this trip (figs. C.18 and C.19).

NOTE

1. Caryl-Sue Micalizio, "Jan 14, 1967 ce: Human Be-In," *National Geographic Society*, accessed December 15, 2019, www.nationalgeographic.org/thisday/jan14/human-be-/.

Gay Demonstrations

contact sheet	
1794 – 1798	San Francisco · Nov 11. 1975
	5 × 7 proofs
1849 – 1855 1876, 1877	New York City · June 25. 1978
	5 × 7 proof
1936 – 1940	New York City · June 24. 1979 Central Park, Christopher St · flash at night
	5 × 7 proofs
1981 – 1985	New York City · June 28 · 1981 Christopher St, Central Park at 79 st. 12 annual March · Christopher St · Liberation Day Committee
	5 × 7 proofs.

FIG. C.16. Undated notebook entry with dates and contact-sheet numbers correlating to "Gay Demonstrations" that Gedney documented. William Gedney Photographs and Papers, Box 176, Folder 2, David M. Rubenstein Rare Book & Manuscript Library, Duke University.

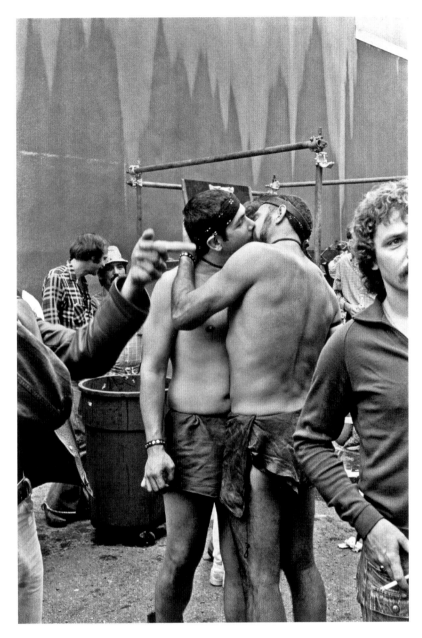

FIG. C.17. *San Francisco, December 1975, Gay Rally*. William Gedney Photographs and Papers, Box 9, Folder 7, David M. Rubenstein Rare Book & Manuscript Library, Duke University.

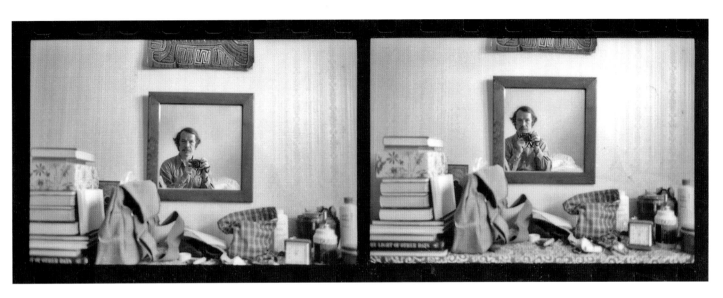

FIG. C.19. Unprinted, untitled self-portrait made in San Francisco, from contact sheet #1835, 1975. William Gedney Photographs and Papers, Box 110, Folder 5, David M. Rubenstein Rare Book & Manuscript Library, Duke University.

(*opposite*) FIG. C.18. Contact sheet #1835, 1975. William Gedney Photographs and Papers, Box 110, Folder 5, David M. Rubenstein Rare Book & Manuscript Library, Duke University.

ACKNOWLEDGMENTS

This book is dedicated to the memory of William Gale Gedney. Thank you, Mr. Gedney, for your extraordinary images, dedication, and foresight.

Countless people have played a role in the care and preservation of William Gedney's archive and the creation of his legacy. However, I would have not have encountered *A Time of Youth* nor any of Gedney's work at Duke University if it were not for the efforts of Robert Byrd, Lee Friedlander, Maria Friedlander, Karen Glenn, Alex Harris, Paula Jeanett, Kirston Johnson, and Margaret Sartor.

And I would not have been prepared for the responsibility of editing this volume if it were not for the mentorship and support of Andy Armacost, Alexa Dilworth, Alex Harris, Wesley Hogan, Ted Mott, Tom Rankin, Courtney Reid-Eaton, and Margaret Sartor.

Thank you to everyone who believed in this book when it was just a seed of an idea and who then helped it to grow. Your collaboration and guidance have made this project possible: Elizabeth Ault, Amy Ruth Buchanan, Philip Gefter, Michael McCullough, and Julie Thomson.

Special thanks to longtime William Gedney champions Alicia Colen, Geoff Dyer, Peter Galassi, Howard Greenberg, Nancy Lieberman, Gilles Mora, Sandra Phillips, and Alec Soth.

I am especially thankful for everyone at Duke University Libraries and specifically the dedicated staff at the David M. Rubenstein Rare Book & Manuscript Library. Gedney's photographs live on because of your continued care, labor, and expertise. Thank you to Deborah Jakubs, University Librarian and Vice Provost for Library Affairs; Naomi L. Nelson, Associate University Librarian and Director, Rubenstein Library; Andy Armacost, Head of Collection Development and Curator of Collections; Aaron Canipe, Alex

Cunningham, Sylvia Herbold, and Rachel Jessen, Archive of Documentary Arts interns; Beth Doyle, Erin Hammeke, Henry Hebert, and Rachel Penniman, Conservation Services; Mike Adamo and Molly Bragg, Digital Collections and Curation Services; Margaret Brown and Yoon Kim, Exhibition Services; David Hansen, JD, and Arnetta C. Girardeau, JD, Office of Copyright and Scholarly Communication; Jennifer Baker, Katie Henningsen, Hope Ketcham Geeting, Megan O'Connell, David Pavelich, and Lucy Vanderkamp, Research Services; Noah Huffman, Paula Jeannet, and Meghan Lyon, Technical Services.

Finally, I would like to express my gratitude to SMU Meadows School of the Arts and my colleagues in the Division of Art. Thank you for encouraging and supporting my research.

—Lisa McCarty

APPENDIX

List of Images and Selected Reflections

LIST OF IMAGES

In most cases William Gedney gave titles only to images that he printed at 11 × 14 inches, essentially exhibition prints. Gedney printed, at most, approximately 20 percent of the photos in the final design for *A Time of Youth* at 11 × 14 inches, so the majority of images featured in the preceding pages have no known title.

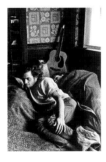 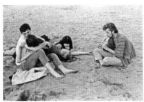 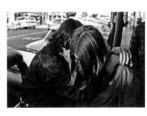 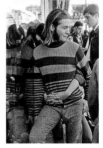

San Francisco, 1966

San Francisco, 1966

San Francisco, 1966

San Francisco, 1967

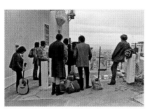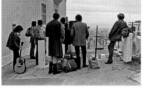 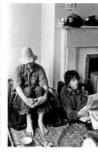 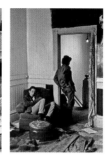

San Francisco, 1966 San Francisco, 1967 San Francisco, 1967 San Francisco, 1967

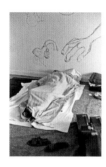 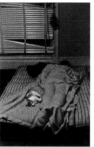 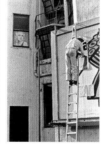 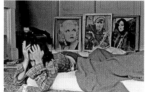

San Francisco, 1965 San Francisco, 1966 San Francisco, 1966 San Francisco, 1967,
John on bed

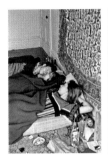 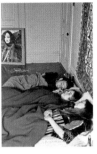 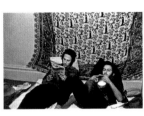 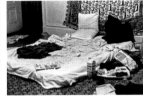

San Francisco, 1967 San Francisco, San Francisco, 1967 San Francisco, 1967
 1967

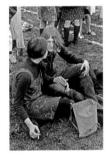 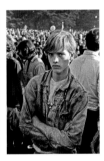 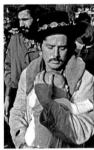 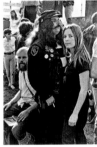

San Francisco, 1967 San Francisco, 1967 San Francisco, 1967 San Francisco, 1967

TRANSCRIPTION OF FIG. A.1

the Grateful Dead (the top band in San Francisco) are blasting

the lobby is jammed. Tinker sees Thumb and makes his way through.

~~The noise of the band and the clothes make it more frantic~~

"Hi Man"

"Hi Tinker"

already close, leans his eyes closer to Tinker's ear

"I've got a present for you"

Thumb reaches deep into the corner of his pocket where the lining is split. withdraws his hand and places it in Tinkers, in the movement of the crowd no one notices movement, he relaxes his fingers and drops a small white tablet about one eight of an inch across and one sixteenth of an inch high into Tinker's palm. Tinkers hand closes over it and he slips it into the watch pocket of his dungarees.

"thanks man" Tinker's face is a broad grin.

"trip easy"

Tinker promotes[?] his way deeper into the mass of people.

the Dead Greatful Dead (the top band in san franiso) are blasting

the lobby is jammed. Tinker sees Thumb and makes his way through.
the noise of the band, ~~and the crowd~~ and the clothe make it more frantic
clostness
- Hi Man
"Hi tinker"
"~~Hi tinker~~ Thumb, already close, leans his lips closer to tinker's ear
" I've got a present for you"
Thumb reaches ~~deep into~~ the corner of his ~~jacket~~ pocket where the leing is split.
the novent of the crowd
withdraws his hand and places it in tinkers, in a ~~crowd of movent~~
no one notice movement, he relaxes his fingers and drops a
small white tablet about one eight of an inch across and one
sixteenth of an inch high. in to tinkers palm. Tinkers hand
~~closes~~ closes over it and he slips it into the watch pocket of his
dungarees .
"Thanks man" ~~his for~~ tinkers face is ~~in~~ a broad grin.
"trip easy"
Tinker promotes his way deeper into the mass of
people .

A cult of Youth 1: Haight Street

Framed in the windows of the passing
bus, passengers heads turn, a row
of mechanical dolls staring bugg-eyed.
~~ancient at the scene~~
An ~~old~~ woman, tightly cluching
handbag, makes her way slowly
through an obstacle course of youth.

Strange garbed youth. Youth restlessly
lounging over parked cars, in doorways,
against store windows, garbage cans,
parking meters, trees, each other. Youth
in dominion of the sidewalk.

Youth restlessly lounging over parked cars,
in doorways, against store windows,
against garbage cans, against parking
meters, against trees, against each other.
Youth in dominion of the sidewalk.

Youth in motion greeting each other.
Boys with hair down to their shoulders
girls with hair down to their shoulders
going barefoot on concrete.

FIG. A.2. Undated journal entry. William Gedney Photographs and Papers, Box 175, Folder 11, David M. Rubenstein Rare Book & Manuscript Library, Duke University.

Youth in motion greeting each other. Boys with hair ~~down to their shoulders~~, Girls ~~going barefoot~~ ~~on concret~~

Boys with hair down to their shoulders and girls with hair down to their shoulders going barefoot on concrete.

Youth in Mexican vests, material of brightness, ~~and~~ dull used army surplus jackets, sandales with bells, hats of ~~all discription~~, stove pipe, caps, turbans, straw hats *hats* *with feathers*

tall boot with ~~fringe~~ *long dangling* sandels, hand decorated clothes in day-glo ... shots.

the woman nagavitale a corador ~~between~~ *through* these alien creatures. She pass almost invisable among them. so preoccupied are they with them selves, age does not exist for them.

<u>Speed kills</u>

~~there is~~ an atmosphere of. garishness sweetened by youth

FIG. A.3. Undated notes. William Gedney Photographs and Papers, Box 175, Folder 2, David M. Rubenstein Rare Book & Manuscript Library, Duke University.

R what do I know of him, what do I want to know? to hold some one in your arms is enough, some one whose being fits yours. to be able to kiss the back of his neck. my lips mingling his soft sandy hair and skin. to have someone hold your hand in the middle of ~~the~~ darkness fingers tenderly interlocked. his arm thrown over your chest, the other under your head. his body next to yours warm, alive, the movement of breathing ~~together~~ together. ~~xxxxxxx~~ to look at the one you love while he is asleep. to wonder at his being, to be bound at the moment of pleasure of his face, his closed lids, his lips that you can not kiss forever. Love is ruled by time and change. the sunset ~~xxxxx~~ ~~x~~ is in motion. it will not last. it must be experienced sensed, felt. ~~x~~ *Now* the photograph of the sunset fake, dead. In harmony with a fellow human being in perfect

FIG. A.4. Undated notes. William Gedney Photographs and Papers, Box 175, Folder 2, David M. Rubenstein Rare Book & Manuscript Library, Duke University.

An old woman, tightly clutching handbag,
makes her way slowly through an obstical course of
youth. Strange garbed youth; youth, restlessly lounging
over parked cars, in doorways, against buildings, store windows,
and each other
store windows, in dominion of the sidewalk.

store windows, parking meters, trees, garbage cans.

Youth restlessly lounging over parked cars, in
doorways, against store windows, garbage cans, parking
meters, trees, and each other, in dominion of the
sidewalk.

FIG. A.5. Undated notes. William Gedney Photographs and Papers, Box 175, Folder 2,
David M. Rubenstein Rare Book & Manuscript Library, Duke University.

At evening after dark, is the other half,
Lighted by space, lies over those that sleep,
Of the single future of night, the single sleep,

As of a long, inevitable sound,
A kind of cozening and coaxing sound,
And the goodness of lying in a maternal sound,

Unfretted by day's separate, several selves,
Being part of everything come together as one.

FIG. A.6. Undated notes. William Gedney Photographs and Papers, Box 175, Folder 2, David M. Rubenstein Rare Book & Manuscript Library, Duke University.

(*opposite and following page*) FIGS. A.7–A.10. Pages from William Gedney's list of words used in San Francisco. William Gedney Photographs and Papers, Box 175, Folder 10, David M. Rubenstein Rare Book & Manuscript Library, Duke University.

Words in use San Francisco
fall 1966

Acid
Acid head
axe

bread
bummer
bum trip
burn
bust
boss
ball a chick
bopper (teenie)
blow your mind
beautiful
boster

(whats) bitching

cop out
crystal
cold
crash (a place to)
contact high
cap

drop (a cap)
dropped
dealer
coming down
drop out

freek out (on)
fuzzy

grease (LA)
grass
gruvey
good people

hip, hippies
head (s)
heat
hang up
H

hype (L.A.)

Jam (split)
hit
lay (some caps on you)
lid

match box

needle freek
Nark

out of sight
(the) outs (L.A)

pin (did you --- that)
pad
pusher
plastic hippie

reds
rightous (super)

split
super high
speed
score
smash
straight
spade

teenie bopper
trip
triping
tough
trip stick

up tight

wow